IMAGES
of America

ENID
1893–1945

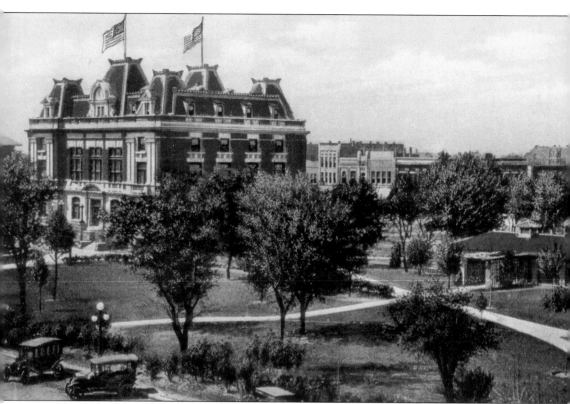

This is the second courthouse building in Enid, which was constructed in 1907 and lasted until it burned in 1931. Standing in the center of the square downtown, it was, for many years, a symbol of the town that had grown up because of the land run. (Author's collection.)

ON THE COVER: Enid's streetcar system began on June 3, 1907, with a fleet of 14 cars. The route was a little less than seven miles long, costing only 5¢ at first. It serviced all railroad stations, the university, and the baseball parks as well as residential and business areas. Here, the streetcar is going north from Maine Street on the west side of the center square of town. (Courtesy of Cherokee Strip Regional Heritage Center.)

IMAGES
of America

ENID
1893–1945

Glen V. McIntyre

ARCADIA
PUBLISHING

Published by Arcadia Publishing
Charleston, South Carolina

Printed in the United States of America

Library of Congress Control Number: 2012932362

For all general information, please contact Arcadia Publishing:
Telephone 843-853-2070
Fax 843-853-0044
E-mail sales@arcadiapublishing.com
For customer service and orders:
Toll-Free 1-888-313-2665

Visit us on the Internet at www.arcadiapublishing.com

*Dedicated to "Aunt Laura," Laura E. Crews (1871–1976),
from one of her great-great-nephews, remembering what
she did to help our family in really hard times.*

CONTENTS

ACKNOWLEDGMENTS

I first want to thank the Cherokee Strip Regional Heritage Center in Enid for all the years I worked there and especially want to thank the director, Andi Holland, who continually prodded me to write this book. Also, I want to thank Aaron Preston, director of the museum's Archives Division, for help both in scanning images and in helping research much of the material. Aaron went above and beyond duty in his help.

I want to thank Bill Welge, director of the Archives Division of the Oklahoma Historical Society in Oklahoma City, for his continuing support and help in accessing the society's images, and Terry Zinn, photograph processing manager at the Oklahoma Historical Society, for compiling the images on CDs.

Many thanks again must go to Mike Tautkis, director of the Kingfisher Memorial Library, for help in scanning some of the images and making sure they were really good scans.

I want to thank Ruth Ann Evans of the Garfield County Public Library for help in getting access to material in the vertical files.

As in past books, I want to thank my good friend Jim Jackson for scouring flea markets to find postcards of Enid that I could use.

I also want to thank the Sons and Daughters of the Cherokee Strip Pioneers for the use of one of the images in their possession.

I want to thank Enid native Bernie Mayer for providing the postcard of the two-man Japanese submarine that was brought to Enid during World War II.

I want to thank Lish Glasser and Gary Brown for their help in learning more about the house at the bottom of page 37.

I would be greatly remiss if I forgot to mention my thanks for Winnie Rodgers Timmons at Arcadia Publishing for her unfailing patience and immense help in making this book happen.

As always, I want to thank my parents, Ray and Kathryn McIntyre, for their love and patience over the years.

I want to finish with a memory of Aunt Laura. She turned 100 in 1971, after the moon landings, and said, "You know, Glen, I would like to homestead on the moon." She would have too.

INTRODUCTION

As of the 2010 census, Enid, Oklahoma, is the eighth largest city in Oklahoma with 49,379 people and lies in northwest Oklahoma in an area of relatively flat plains, sloping gently from west to east. Enid is the county seat of Garfield County, which was originally called "O" County until an election in 1894 named it for Pres. James A. Garfield who had been assassinated in 1881.

The town was named by railroad official M.A. Low, who was fond of the poem, "The Idylls of the King" by Alfred Lord Tennyson. One of the heroines of this poem was Enid the Fair. Low chose the name Enid because he did not want the town to be called Skeleton, the name of a nearby ranch. Some people believe that the town was named after a "dine" sign that fell off a tent and was found upside down, hence "Enid." This is almost certainly not the case.

Enid is located in what was once the Cherokee Outlet, more popularly known as the Cherokee Strip. The real Cherokee Strip was a 2.5-mile-wide stretch of land along the north side of what is now Oklahoma that was disputed between the Cherokees and Kansas. The Cherokee Outlet was some 60 miles north to south and 90 miles east to west and originally had been set aside as a corridor for the Cherokees in northeast Oklahoma to hunt game on the plains. During the late 1880s, large cattle companies banded together as the Cherokee Strip Livestock Association to rent the outlet from the Cherokees.

On April 22, 1889, a land run opened a center portion of what is now Oklahoma. More land runs followed in 1891 and 1892, and so by 1893, large portions of Oklahoma had been opened by settlement. In 1893, the government agreed to buy back the outlet from the Cherokees and did so for $8,595,736.12, which the Cherokees insisted be paid for in gold.

In the summer of 1893, some 6.5 million acres were surveyed so that settlers ran for farms of 160 acres. The Cherokee Outlet was opened by a land run on September 16, 1893, with over 100,000 people running for some 40,000 possible claims.

Many settlers came from southern Kansas, which had suffered in the late 1880s from droughts and locusts. While many raced for 160 acres of land to farm, some raced to start new lives in towns in the outlet, of which Enid was the largest.

On September 16, 1893, some 15,000 discovered the original townsite of Enid extended from present-day Washington Avenue on the west to Tenth Street on the east. From present-day Owen K. Garriott Road, it extended north to Randolph Avenue for a total of 320 acres. The Rock Island Railroad (Chicago, Rock Island & Pacific) already went through the area, having been built in 1889. It passed north-northeast to south-southwest through the land set aside for Enid but did not stop, as the Rock Island Railroad depot was in North Enid.

North Enid lay just three miles to the north of Enid. It had been chosen as the depot because of malfeasance within the Department of Interior. When the Cherokees sold the Cherokee Strip back to the federal government, the Cherokee reserved the right to have up to 70 allotments set aside so that some Cherokees would own land in the outlet.

The Department of Interior had designated what is now North Enid to be the county seat and the location for the land office for where settlers would come to register their claims in what

was still "O" County. The Rock Island Railroad decided that this original Enid would be where it placed its depot. The location of the town was an open secret, and Robert L. Owen, later US senator from Oklahoma, encouraged Cherokees to take allotments in the new town.

Hoke Smith, secretary of the Department of the Interior, found out and was angry. He then changed the location for the county seat and the land office to another site, three miles south of the original designation. So this new town became Enid, and the old town became North Enid, even though the railroad refused to recognize the new Enid and trains roared through the new town as if it did not exist. The settlers of Enid decided to take care of this problem themselves, sawing the timber supports of one of the bridges that went through Enid so that bridge collapsed and the train did stop. US marshals had to be called out as mob violence threatened to take over. On August 8, 1894, Congress passed an act calling for a railroad depot within a fourth-mile of any townsite in the territory.

Settlers spilled over to the north of the designated town, and this area became known as "Jonesville." Jonesville bordered the town on its northeast side, running from Grand Avenue on the west to Seventh Street on the east. On March 6, 1895, the settlers of Jonesville asked to become a part of the greater city of Enid. Being platted in 1894, the Kenwood addition was the first main addition to the town to the west. Enid has continued to grown ever since, with numerous large mansions from this period that survive to this day.

Enid became the center for four major railroad lines, the Rock Island (the Chicago, Rock Island & Pacific), the Frisco (St. Louis & San Francisco), the Santa Fe (Atchison, Topeka & Santa Fe), and the Katy (the Missouri, Kansas & Texas), along with important branch lines, such as the Denver & Gulf line. These railroads made Enid a hub of commerce for the whole area. The railroads encouraged huge grain elevators to store the wheat grown in the area.

On September 9, 1916, the Hoy No. 1 well came in halfway between Garber and Covington, initiating the Garber-Covington oil field. This became one of the world's greatest producers of crude oil in the 1920s and started the careers of such men as H.H. Champlin.

The story of Enid is enriched by the lives of many people like Marquis James, author and winner of two Pulitzer prizes; H.H. Champlin, founder of Champlin Petroleum; and Laura Crews, the last of the Cherokee Strip pioneers to die, to name a few.

This book covers the period from 1893 to 1945. Chapter 1 covers the beginnings of the town, while chapter 2 shows the town as it develops and grows. Chapter 3 describes how Enid citizens earned a living, and chapter 4 shows us some of the schools, churches, and hospitals that grew up during this time. Chapter 5 details the people who made this city special, and chapter 6 shows the triumphs and trials that defined Enid in the years 1929–1945. The book concludes in chapter 7 with how the people of Enid have had fun over the years, from fairs to football, baseball, bands, and of course, parades.

Enid: 1893–1945 shows the town in a golden age.

One

BEGINNINGS

By the time the Cherokee Strip came to be open, Oklahoma had already been settled with the land runs of 1889, 1891, and 1892, which opened roughly the center one-third of Oklahoma. The federal government, which oversaw the land runs, had experienced problems with sooners (people who sneaked into land run areas before the allotted time). So the government decided that settlers had to register at booths before they made the land run. There were booths at Kiowa, Cameron, Caldwell, Hunnewell, and Arkansas City, Kansas. There were also booths at Orlando, Hennessey, and Stillwater, Oklahoma, and one partway between Higgins, Texas, and Goodwin, Oklahoma. Settlers would receive a certificate at one of these booths that they would then later present to the officials at the land offices when they registered their claims. About 115,000 certificates were issued, but unfortunately, the government had failed to provide enough clerks to cover the number of applicants, and so thousands had still not been registered when time came for the run. Thus, sooners were able to claim that they had waited in line for a certificate but did receive any. So the problem of sooners remained. One historian claimed that the proportion of sooners was as high as 33 percent in the areas closest to the Kansas line.

At high noon on September 16, 1893, the settlers began, with some racing south from Kansas and some racing north from the portions of Oklahoma that had already been settled by earlier land runs. Settlers used every means possible, like horses, wagons, bicycles, and even on foot, to get into the land. With the Rock Island Railroad already going through Enid, many settlers rode on the trains, which supposedly went no faster than the fastest horse could ride.

Though many settlers had come for land in the countryside, some came to Enid to claim a city lot, which was a half acre. The settlers paid the government the $14 fee for the town lot and then went on to establish a new life. On September 30, 1893, Enid Mae McKinzie was born, supposedly the first baby born in Enid. (There are other candidates for the post, however.)

The settlers came as lawyers, doctors, restaurant owners, hardware store owners, soft drink sellers, and numerous other professions.

They did not live in tents very long.

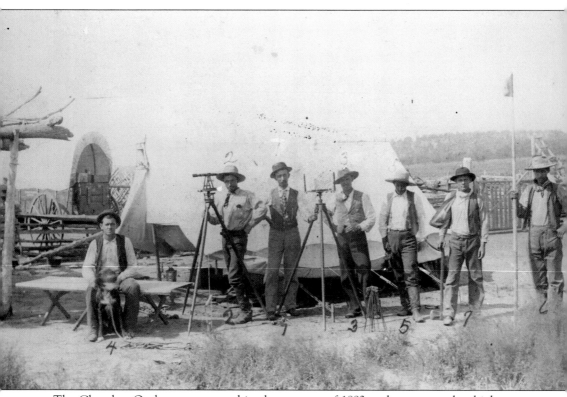

The Cherokee Outlet was surveyed in the summer of 1893 and was opened at high noon on September 16, 1893. This photograph, taken in July 1893, is of the men performing the survey next to the Arkansas River where the town of Cleveland, Oklahoma, now stands. (Courtesy of Archives Division, Oklahoma Historical Society.)

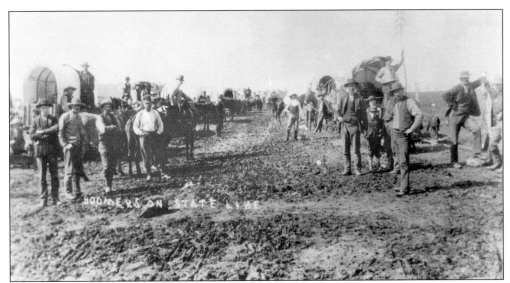

The settlers waited both in Kansas and old Oklahoma. Here are settlers, mistakenly called "boomers," waiting on the Kansas-Oklahoma boundary. The original boomers were people who had promoted the opening of Oklahoma to settlement. The terms later became confused. (Courtesy of Cherokee Strip Regional Heritage Center.)

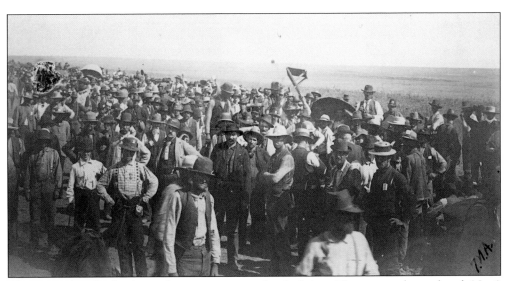

There were booths for the settlers to register at ahead of time. Here are settlers at booth No. 9 in Arkansas City, Kansas, on September 11, 1893. (Courtesy of Archives Division, Oklahoma Historical Society.)

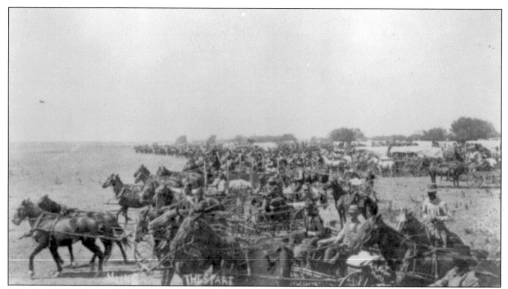

The land run consisted of the northwest portion of Oklahoma and included all or part of 11 counties. Settlers ran for over 40,000 claims, totaling 160 acres of land apiece, as well as for lots in the towns. In this picture, the gun has just sounded, and the race has started; however, no one has really got up any momentum yet. (Courtesy of Cherokee Strip Regional Heritage Center.)

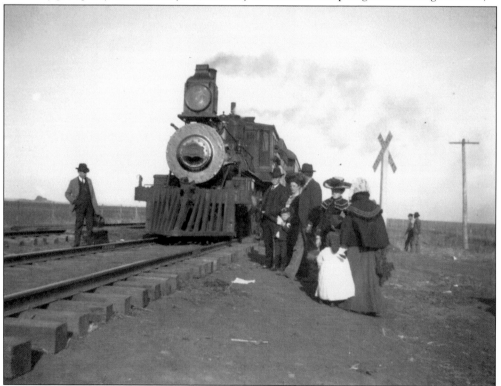

Some came on the train, which could go no faster than the fastest horse. This photograph is believed to be of people getting off the train at Shea siding, now in Enid, though it may not have been taken on the day of the run itself. (Courtesy of Cherokee Strip Regional Heritage Center.)

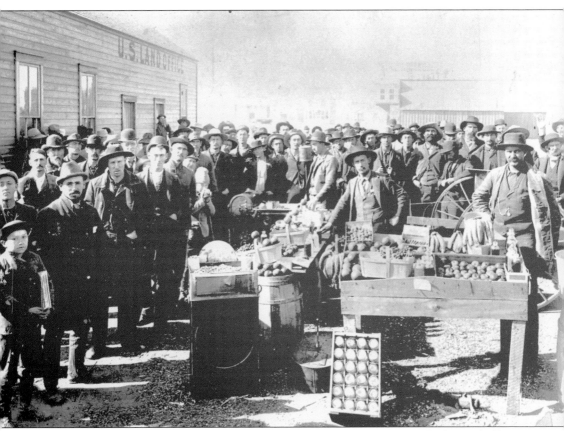

Settlers came to Enid to register their claim at the land office. In this photograph, the land office is to the left, and the crowd in front is waiting to register claims. The land office sat just a little to the east of the present-day library, and today, the building sits on the grounds of the Cherokee Strip Regional Heritage Center. Here, enterprising men are selling fruit to settlers as they wait in line. They also sold sandwiches, coffee, and even water. (Courtesy of Cherokee Strip Regional Heritage Center.)

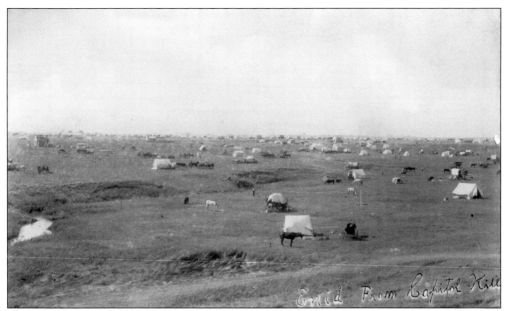

At first, Enid was just a tent city. Here is a photograph looking across from the east at what was just becoming Enid, from an area then called Capital Hill. It is roughly a little to the west of the spot where the Cherokee Strip Regional Heritage Center is located today. (Courtesy of Cherokee Strip Regional Heritage Center.)

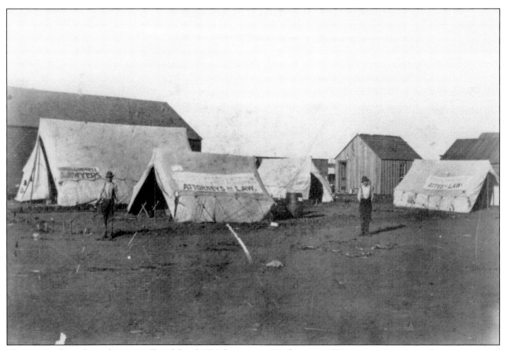

Two months after the run, Enid had 174 lawyers, 10 doctors, 20 grocery stores, 6 newspapers, 10 hardware stores, 46 cafés, 10 lumberyards, and 37 saloons. The large number of lawyers was presumably for settlers to deal with numerous disputes over claims for land. (Courtesy of Cherokee Strip Regional Heritage Center.)

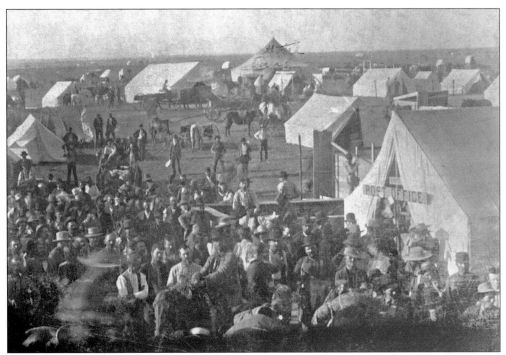

Of course, the post office was originally housed in a tent. Postmaster Robert M. Patterson and his assistant Pat Wilcox erected this 12-by-14-foot tent. It sat just south of the land office for two weeks and then was moved to the south side of the 100 block of Broadway. (Courtesy of Archives Division, Oklahoma Historical Society.)

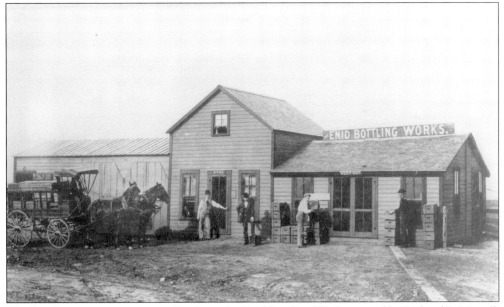

The first business in operation in Enid was the Enid Bottling Works, owned by Richard E. Messall. The almost 19-year-old Messall brought in lumber, acquired a town lot, assembled the building, and was in business within 48 hours. This building stood at 923 East Broadway. (Courtesy of Cherokee Strip Regional Heritage Center.)

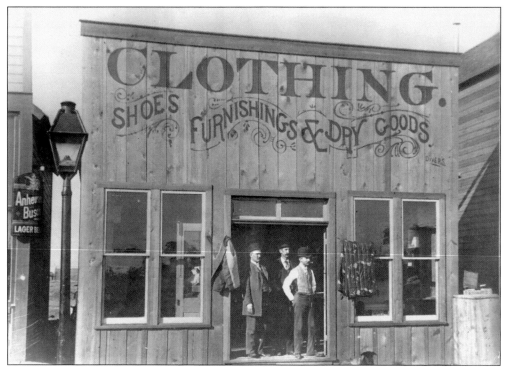

Marinus Gottschalk established Enid's first clothing store in 1893 at the corner of Maine and Independence Streets. Of the men in the photograph, the one on the left is Dr. C.F. Champion (see chapter 5). The one on the right Gottschalk, and the one in the center is unidentified. Gottschalk was a member of Enid's Jewish community. (Courtesy of Cherokee Strip Regional Heritage Center.)

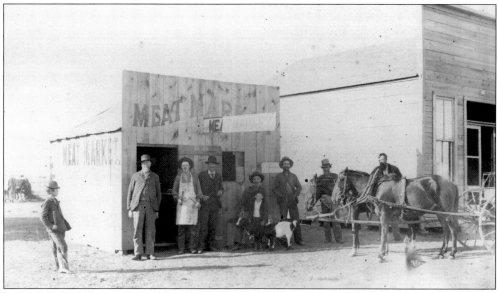

Meat markets were naturally in demand. This may be the meat market that Louis A. Faubion started on the northeast corner of the square in 1896. (Courtesy of Archives Division, Oklahoma Historical Society.)

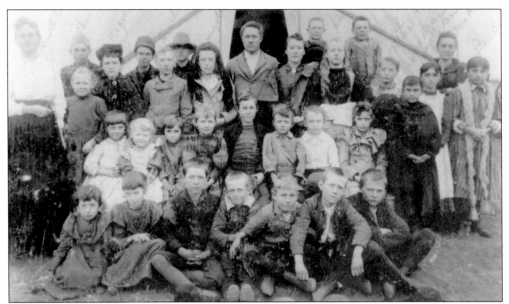

In 1893, Jessie Livingston (standing at left) started a subscription school held in a tent, located at Grand and Maple Avenues. Livingston charged each pupil $1.50 a month and eventually had 39 students. Those identified are, in no particular order, Charles Stanton, Regina Neville, Orville, Myrtle Cunningham, Lou Dillon, Gertrude Hall, Johnny Nevile, Lula Clevinger, Ethel Cropper, Jessie Bennett, Myrtle Bennett, Mrs. Brett Bennett (standing, second from right), and Pat Bennett. (Courtesy of Cherokee Strip Regional Heritage Center.)

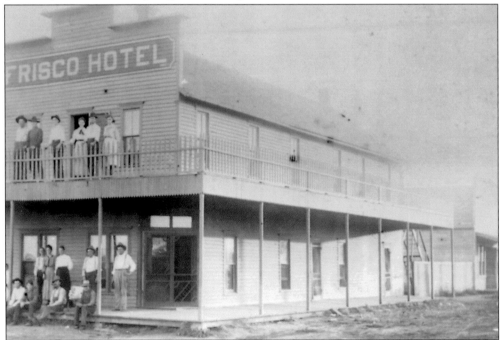

Considering many men were bachelors, hotels were very important. The Frisco Hotel was on 213 West Walnut Avenue and was owned by a Kate Smith in 1926. (Courtesy of Cherokee Strip Regional Heritage Center.)

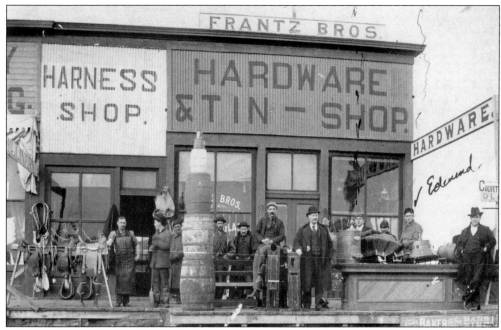

There were six Frantz brothers, all of whom would make their mark on the Enid area. Edmund was the first to come to Enid, starting up the Frantz Brothers Hardware store. This was the first store on the west side of the square; see chapter 5 for more on the Frantz family. (Courtesy of Archives Division, Oklahoma Historical Society.)

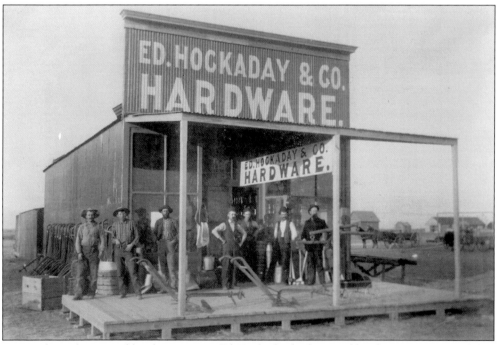

Many others also started hardware stores. Ed Hockaday had opened his first store in Kingfisher after the land run of 1889 and operated 14 different stores throughout Oklahoma by the time of his death in 1921. (Courtesy of Cherokee Strip Regional Heritage Center.)

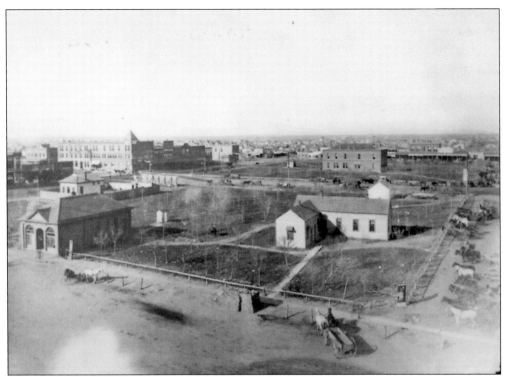

Soon, the center of town became recognizable. The land office is the main building in the center right, with the post office to the left. In the background is the first courthouse building, constructed in 1896. (Courtesy of Cherokee Strip Regional Heritage Center.)

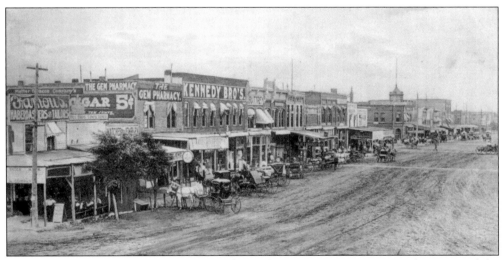

This is the east side of the square. Kennedy Brothers store is prominent in the center of the block. The signs also indicate that the Gem Pharmacy, Hill Brother's Confectionery, Famous Haberdashers and Tailors, a buttery, dentist, and the White Rock Saloon filled up this part of the square. In the distance, one can make out Tony Faust Saloon. (Author's collection.)

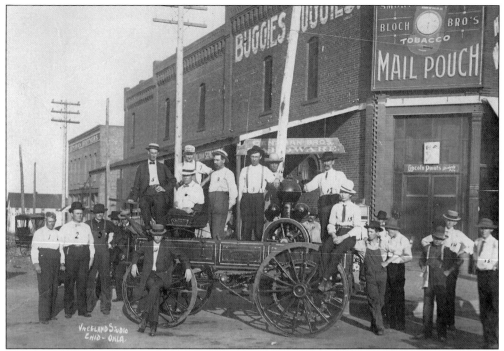

These are early-day town leaders. Though they are photographed with a fire engine, those pictured are most likely not volunteer firefighters. The men are identified as follows: 1.) a "drunk." 2.) D.B. Maupin, 3.) E. Arends, 4). C.C. Hoyt, 5.) D.P. Alderson, 6.) W.R. Gensman, 7.) Red Grupp, 8.) G.T. Gensman, 9.) F.C. Gensman, 10.) Charles Hackett, 11.) R.R. Parrish, 12.) D.C. Powers, 13.) John Nelson, 14.) N.T. Myer, and 15.) Marquis James. (Courtesy of Cherokee Strip Regional Heritage Center.)

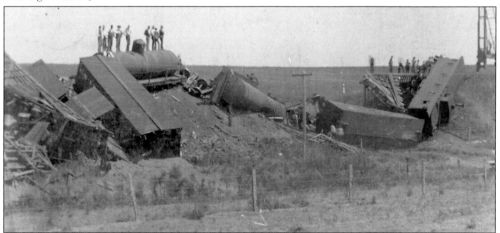

As mentioned in the introduction, the Rock Island Railroad had a depot in what is now North Enid, which the railroad considered Enid, and would not stop at Enid, which the railroad called South Enid. So on Friday, July 13, 1894, the citizens of Enid took the law into their own hands. They used a large saw to undermine the timber supports of a railroad bridge on the south side of town. The next time the train came through, the bridge collapsed. No casualties were recorded. The supposed saw is on display at the Cherokee Strip Regional Heritage Center. (Courtesy of Cherokee Strip Regional Heritage Center.)

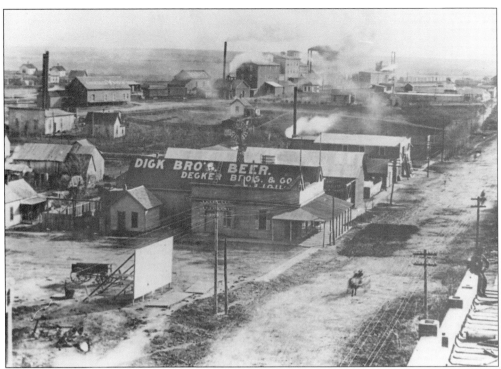

This photograph is looking south on Grand Avenue toward the Rock Island Railroad. The headquarters of Dick Brothers Beer is in the center of the picture. (Courtesy of Cherokee Strip Regional Heritage Center.)

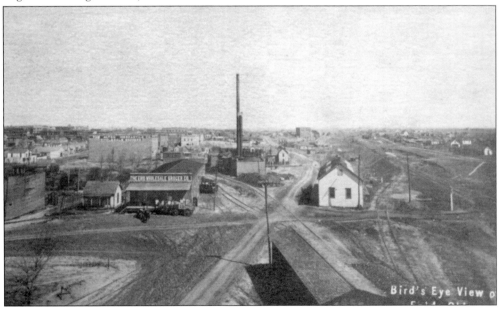

Here is a bird's-eye view of the northeast side of town about 1900. The Enid Wholesale Grocers, with its office at 115 East Maple Avenue, is the small building in the center of the picture. The Alton Mercantile Building at 200–208 East Maple Avenue is farther in the background to the left. (Courtesy of Archives Division, Oklahoma Historical Society.)

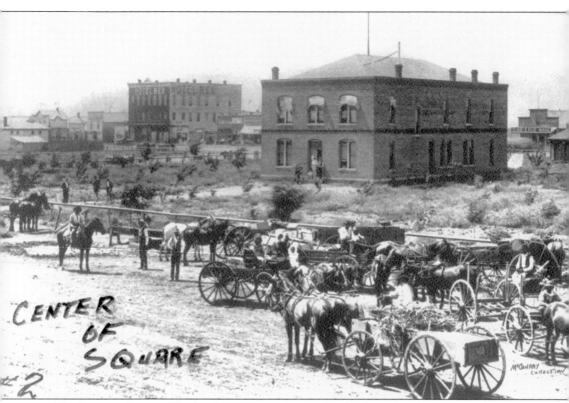

The first courthouse of Enid was an upstairs room in the first brick building in Enid, belonging to Hockaday and Henry. In 1896, businessmen raised the money to build the first actual courthouse building. It is pictured here around 1900 with the square around it. (Courtesy of Cherokee Strip Regional Heritage Center.)

Two

THE TOWN GROWS

The first addition to Enid was the "Jonesville" area. This location consisted of settlers that had spilled over from the original city. Jonesville sat on the northeast side of Enid, running from Grand Avenue on the west to Seventh Street on the east and from Randolph Avenue on the south to Chestnut Street on the north. On March 6, 1895, the settlers of Jonesville asked to be brought into the greater city of Enid, and this was agreed to in a special election that summer.

The Kenwood District to the west was claimed in the run by Maurice Wogan and N.E. Sisson and platted on April 16, 1894. Wogan improved the land under the "ten dollar act," which allowed improvements to the land for townsite purposes. In 1895, the land was sold to the Kenwood Land and Development Company, owned by Harrison Lee and W.O. Cromwell, who sold lots for as low as $25 apiece.

An addition immediately to the south of the town was platted by James T. Douthitt, whose wife, Dolly, later became infamous for killing her husband.

The center of the town became the square, and most major businesses grew up there. To the east of town, Oklahoma Christian University became Phillips University (see chapter 4).

The west side of town became the location of many beautiful homes, and fortunately, many are still standing today.

In 1900, Enid had 3,444 people. In the 1907 statehood census, there were 10,087 people, and in the 1910 census, Enid boasted 13,799.

With the discovery of oil in 1916 in the Garber-Covington oil field to the east of town (see chapter 3), Enid became one of the wealthiest towns in Oklahoma.

Construction material could be found all over town. This pre-1907 view looks down on the cast stone supply yard of C.C. White, Modern Builder. (Courtesy of Cherokee Strip Regional Heritage Center.)

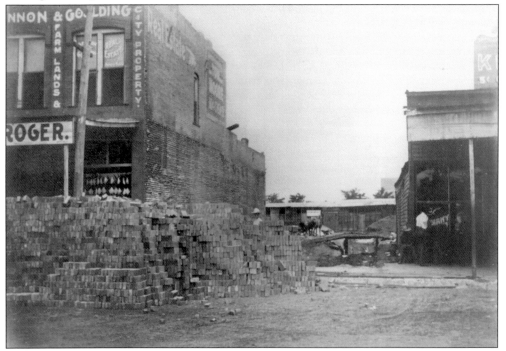

Bricks came from a brickyard on the south side of town, located not to far from the present-day landfill. (Courtesy of Cherokee Strip Regional Heritage Center.)

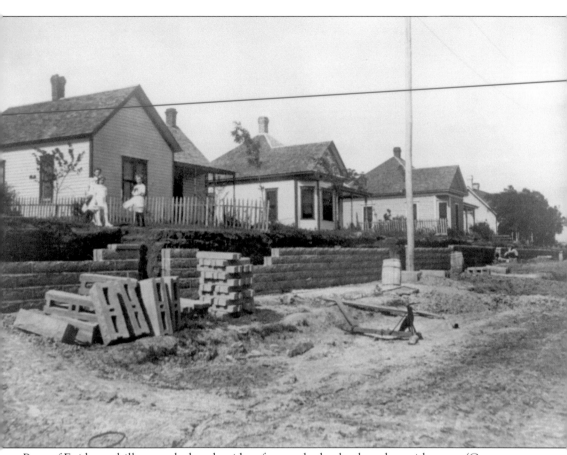

Parts of Enid were hilly enough that the sides of streets had to be shored up with stone. (Courtesy of Cherokee Strip Regional Heritage Center.)

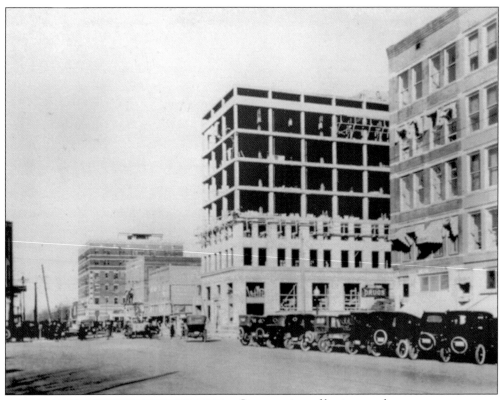

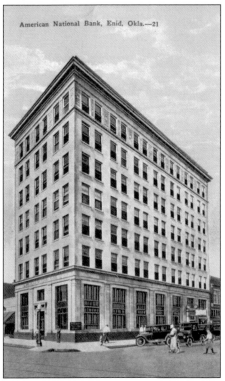

American National Bank, Enid, Okla.—21

Construction of businesses downtown was important. This is the American National Bank under construction on the corner of Randolph and Grand Avenues. This view is looking north down Grand Avenue, with the Loewen Hotel being the next big building to the north. (Courtesy of Cherokee Strip Regional Heritage Center.)

Here is the American National Bank Building completed. It was the First National Bank in the 1940s. (Courtesy of Archives Division, Oklahoma Historical Society.)

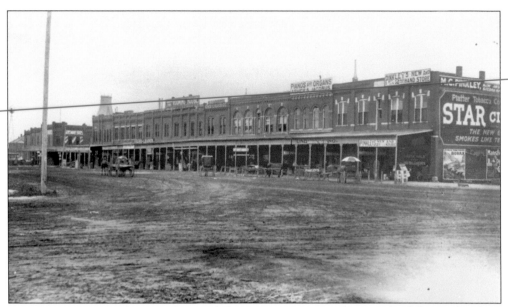

Most activities in Enid centered around the square. Here is a photograph of the south side of the square before the fire of 1901. In the middle, there is a sign for Asher & Jacobus, Pianos and Organs. On the corner is Pinkley's New and Second-Hand Store. The Enid Liquor Company was also in this block, and a sign advertises a rooming house. A windmill can be seen in the background. (Courtesy of Archives Division, Oklahoma Historical Society.)

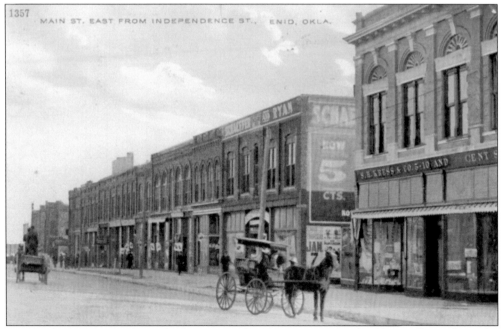

Here is the same general area looking east. The S.H. Kress & Co. building still stands on the south side of the square as part of the Cherokee Strip Conference Center. A poster on the side of one of the buildings advertises what seems to be a play called *Man in the Moon* to be performed on Thursday, January 7, in either 1904 or 1909. (Courtesy of Cherokee Strip Regional Heritage Center.)

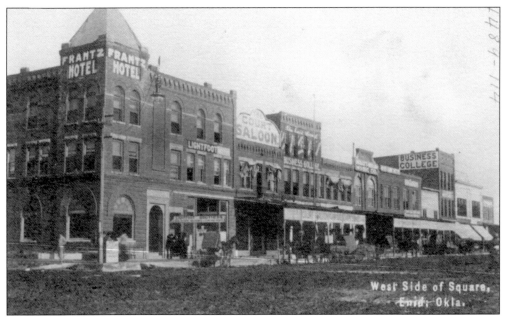

This is the west side of the square with the Frantz Hotel on the corner. Lightfoot Brothers, Real Estate, Cash & Loans is next to it. To the north are the Court Saloon and the Court Saloon Furniture and Carpets, with the Enid Business College over it. Then, there is a music company whose name is unclear. (Courtesy of Archives Division, Oklahoma Historical Society.)

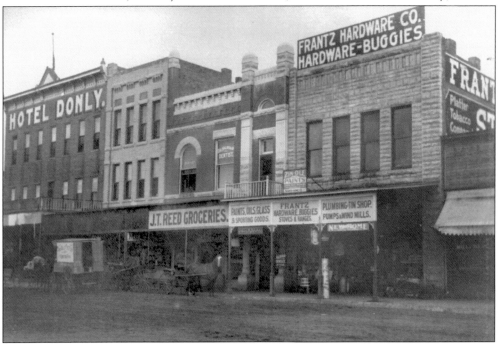

Taken around 1900, this close-up shows the west side of the square with the Frantz Hardware store in the center. At one corner is the Hotel Donley. J.T. Reed Groceries occupies this block as well as a store that advertises "Paints, Oils, Glass & Sporting Goods" and the dentist office of Dr. Halderman. (Courtesy of Cherokee Strip Regional Heritage Center.)

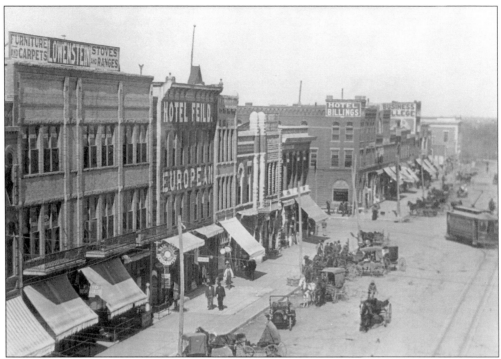

Here also is the west side of the square. The Hotel Billings is another incarnation of the Hotel Frantz. Next to it is Lowensten Furniture. Adjacent to it is the Hotel Field .The circular sign says, "Baseball Headquarters, billiards and cigars." Since the streetcars are in operation, this photograph was taken after 1907. A portent of the future is a single car parked in the middle of the picture. (Courtesy of Cherokee Strip Regional Heritage Center.)

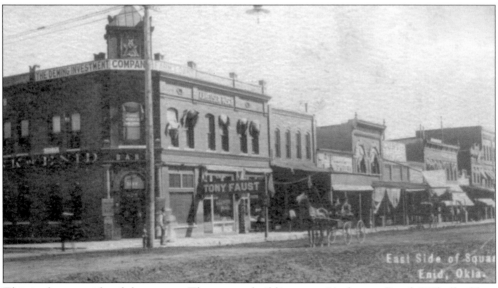

This is the east side of the square. The corner building says, "Anheuser Busch." The building contains the Bank of Enid. Next to it is the Tony Faust Saloon, then a jewelry store. (Courtesy of Archives Division, Oklahoma Historical Society.)

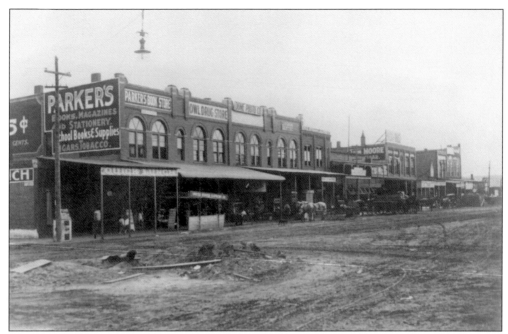

This also is a photograph of the east side of the square. The first building on the left housed the Parker Bookstore on the second floor and Quick Lunch on the first. Down the way from these two businesses are the Owl Drugstore, the Dome Photo Company, the United States Express Company, Enid Steam Laundry, and a dentist. (Courtesy of Cherokee Strip Regional Heritage Center.)

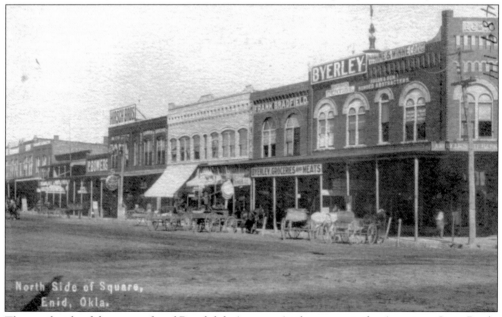

The north side of the square faced Randolph Avenue. At the corner is the American State Bank. Just to its west is the Byerley Groceries and Meat Market. Upstairs are the dentist office of Dr. Entriksen and the workplace of Fagan and Sons, bonded abstracters. Farther still to the west are Hirsch Brothers, P. Bowers, and a hardware store. (Courtesy of Archives Division, Oklahoma Historical Society.)

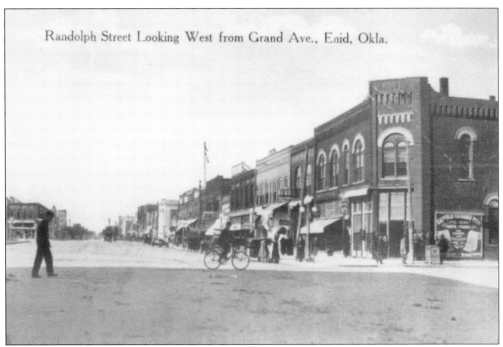

Here is a later picture of Randolph Avenue looking west from Grand Avenue along the north side of the square taken around 1900. (Courtesy of Cherokee Strip Regional Heritage Center.)

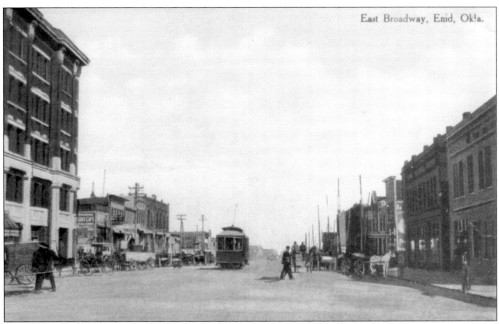

This is looking east along Broadway. The Crescent Café can barely be seen on the left, and farther down the block, a sign indicates the location of a feed store. Again this is after 1907 as a streetcar is prominent in the picture. (Author's collection.)

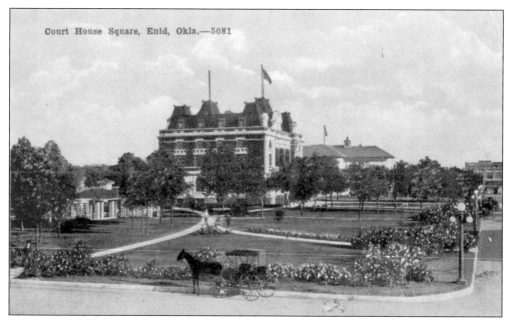

Court House Square, Enid, Okla.—5081

In the center of the square sat the Empire-style courthouse. Though technically the third courthouse in Enid, it was actually the second courthouse building, constructed in 1907. (Courtesy of Cherokee Strip Regional Heritage Center.)

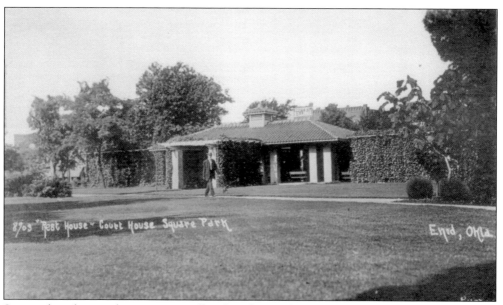

8703 "Rest House" Court House Square Park Enid, Okla.

Surrounding the courthouse was a small park with a rest house and gardens. (Author's collection.)

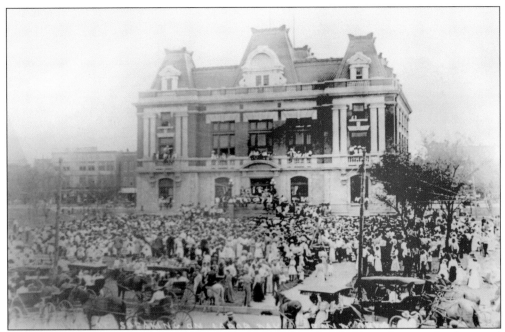

The courthouse was the center for many activities. This is probably a photograph of a crowd gathered to hear Thomas P. Gore speak on Labor Day 1907. (Courtesy of Cherokee Strip Regional Heritage Center.)

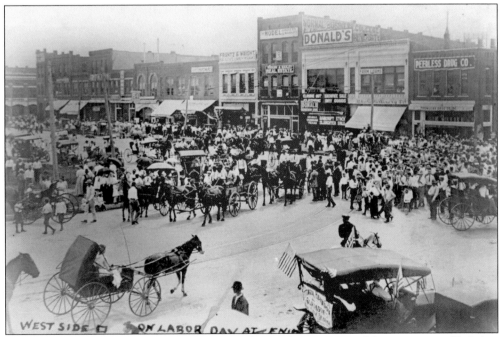

Here is another picture of a crowd gathering on the northwest corner of the square, possibly Labor Day 1909. (Courtesy of Cherokee Strip Regional Heritage Center.)

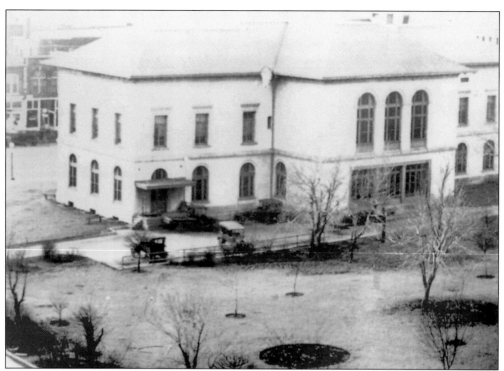

The old post office was succeeded by a much larger building that stood where the present-day library stands. It was built about 1912. (Courtesy of Cherokee Strip Regional Heritage Center.)

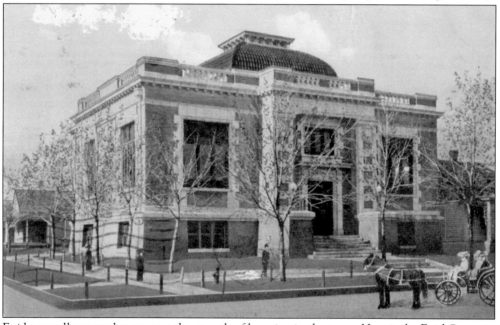

Enid naturally wanted to support the growth of learning in the town. Here is the Enid Carnegie Library at 402 North Independence Street. It opened August 1, 1910, and was one of 24 Carnegie libraries built in Oklahoma. Unfortunately, this later fell into neglect and was torn down in 1972. (Courtesy of Cherokee Strip Regional Heritage Center.)

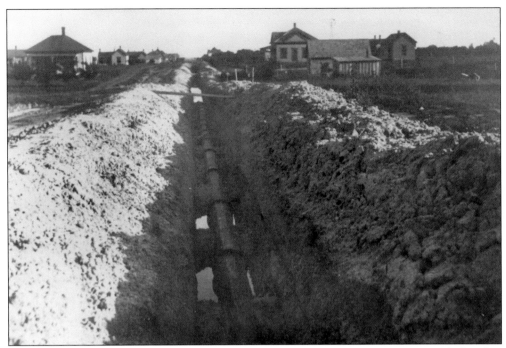

More prosaic items were needed as well. Here is a water line being laid. (Courtesy of Cherokee Strip Regional Heritage Center.)

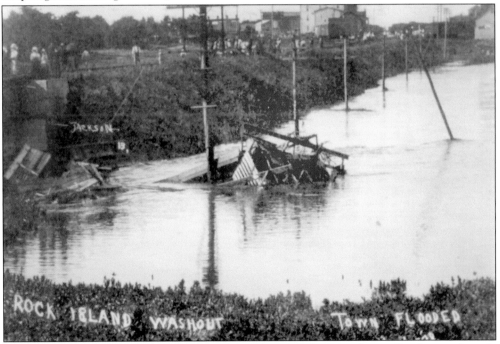

Like many other towns, Enid has seen its share of natural disasters. Boggy Creek runs through the middle of Enid and occasionally floods. Here is a photograph of the flood of June 6, 1908, showing where it washed out the Rock Island line. (Courtesy of Cherokee Strip Regional Heritage Center.)

Any self-respecting town had grand houses to show how prosperous the community was. This is Broadway looking west around 1900. (Courtesy of Cherokee Strip Regional Heritage Center.)

This is probably a close-up of the same scene around 1910. (Courtesy of Archives Division, Oklahoma Historical Society.)

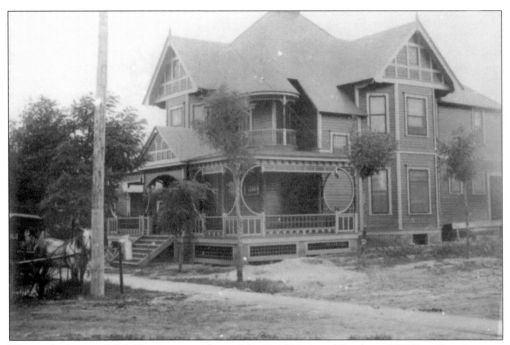

This is the home of O.J. Fleming, president of the Enid National Bank, at 502 West Pine Avenue. (Courtesy of Cherokee Strip Regional Heritage Center.)

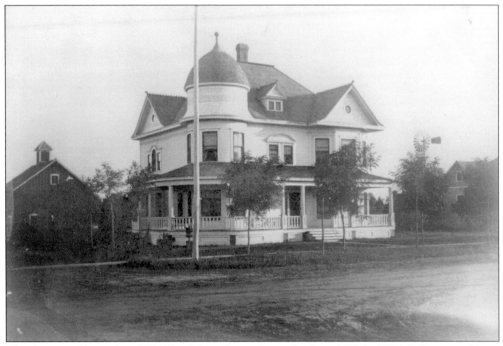

This house still stands at 701 West Main Street. It was built in 1910 by R.W. Sullivan and later became the Fossett Funeral Home. (Courtesy of Cherokee Strip Regional Heritage Center.)

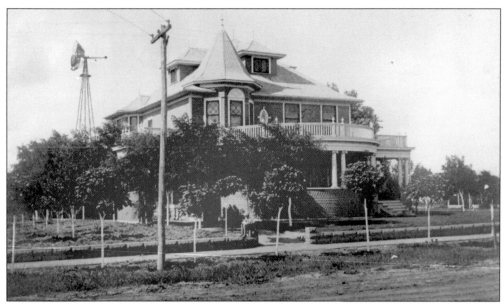

This is the home of Louis A. Faubion at 305 North Independence Street. In addition to the meat market mentioned in chapter 1, Faubion had a furniture store at 107 South Grand Avenue and a secondhand store at 131 East Maine Street. (Courtesy of Cherokee Strip Regional Heritage Center.)

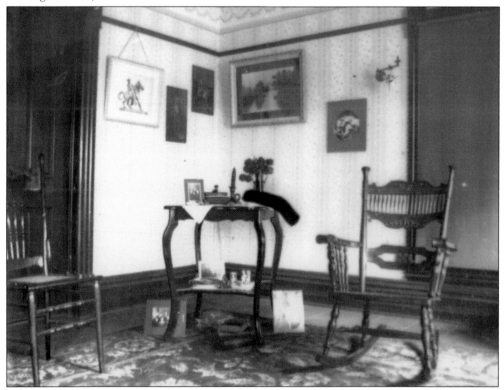

Interiors were simple at first and then gradually became more elegant. Pictured is the interior for an unidentified home about 1900. (Courtesy of Cherokee Strip Regional Heritage Center.)

Three

MAKING A LIVING

Enid in the beginning was primarily a market town for the large agricultural area that surrounds it. The town lies at the center of a major wheat-growing area. In the 1893–1945 period, many families still lived on their 160 acres of land acquired during the land run, and almost all grew what is called Hard Red Winter Wheat. It is planted in the fall and then harvested at the end of May or the beginning of June, and farmers grow it to this day.

The farmers would come to town to get groceries, clothes, and hardware; to consult doctors, dentists, and, if need be, lawyers; and to dine at early versions of fast food restaurants.

All of this was possible because Enid was the hub for four major railroad systems: the Rock Island (Chicago, Rocks Island & Pacific), the Santa Fe (Atchison, Topeka & Santa Fe), the Frisco (St. Louis & San Francisco), and the MK&T (Missouri, Kansas & Texas). The railroads delivered almost anything a farmer or his wife wanted through the Sears Roebuck and Co. catalog or the Montgomery Ward catalog, including a complete house. Still, many preferred to go into town to purchase their needs.

Numerous other professions naturally came to Enid, such as newspapers or the Western Union telegraph office. Schools were needed, and so were hospitals and churches.

Once oil was discovered in the Garber-Covington oil field in 1916, money started to pour into the town, and what had once been a fairly prosperous town catering to the farmers of the area became a center for real wealth.

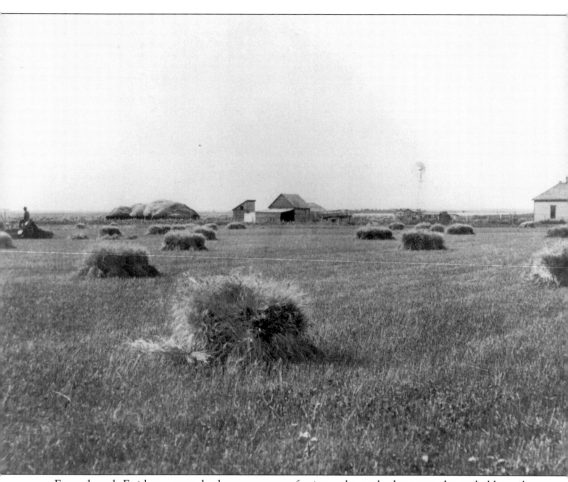

Even though Enid as a town had numerous professions, the early-day town depended heavily on farmers in the countryside for trade. The farmers almost exclusively grew what is called Hard Red Winter Wheat. It is planted in the fall and then harvested the last of May or the first of June. Newer varieties of Hard Red Winter Wheat are still grown around Enid. (Courtesy of Cherokee Strip Regional Heritage Center.)

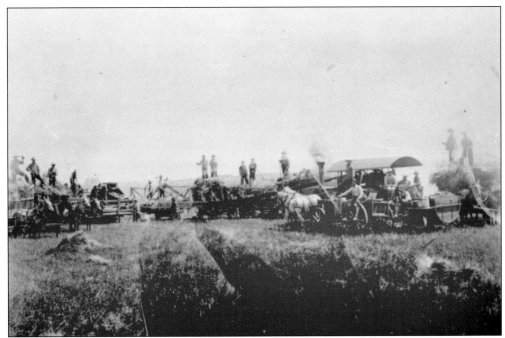

A full harvesting crew consisted of about 20 men. An average day's cutting was 12 to 15 acres, but 20 acres could be cut on a really good day. (Courtesy of Cherokee Strip Regional Heritage Center.)

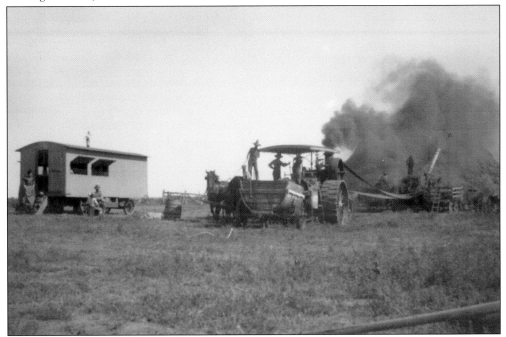

The wheat would then be threshed, which separated the hull from the grain. In this picture, the building on the left is the cook shack where the women would prepare meals for the men, who often worked late into the night. A big day's threshing would be 300 bushels of wheat. (Courtesy of Cherokee Strip Regional Heritage Center.)

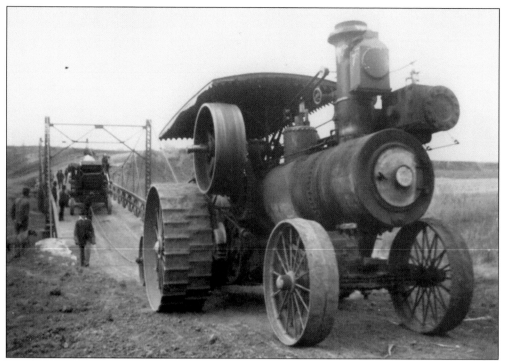

Pictured is one of the gigantic steam engines that propelled the threshing machines. The wheel on the left would be connected to the threshing machine by large belts. This photograph shows a threshing crew crossing over Skeleton Creek on a suspension bridge south of Woodring Airport, located one mile south from Thirtieth and Market Streets and one mile east. (Courtesy of Cherokee Strip Regional Heritage Center.)

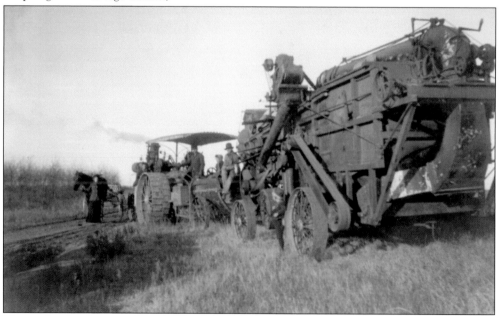

Here is the threshing machine itself. The men are threshing wheat in the Pioneer High School area. (Courtesy of Cherokee Strip Regional Heritage Center.)

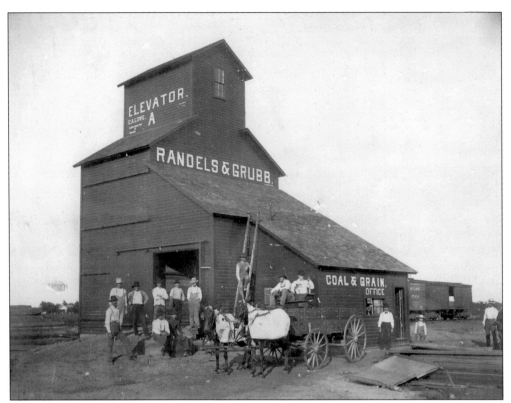

The harvested grain would then be taken to town to be sold at the elevator. The office for this elevator was in the Enid National Bank. (Courtesy of Cherokee Strip Regional Heritage Center.)

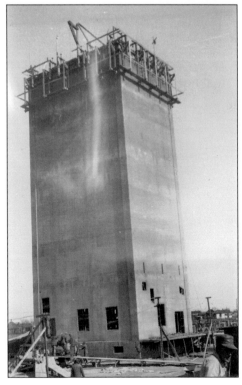

Enid became the center for wheat storage in the area. The Union Equity Company began in 1926 and was founded by E.N. Puckett. Eventually, it would operate four grain elevators with a combined storage capacity of over 50 million bushels. Here is a photograph of the construction of the first elevator around 1929. (Courtesy of Archives Division, Oklahoma Historical Society.)

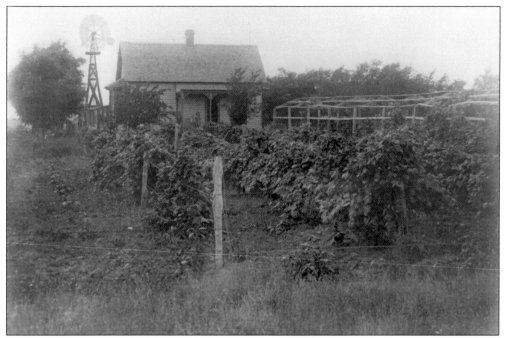

Even in those days, a few farmers experimented with grapes. Unfortunately, this farm is not identified. More recently, to the west of Enid along Highway 412, several new vineyards have sprung up. (Courtesy of Cherokee Strip Regional Heritage Center.)

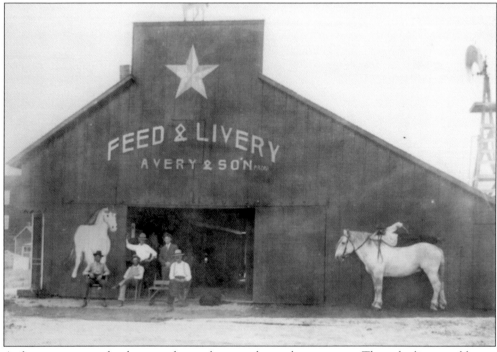

At first, everyone rode a horse or drove a buggy or horse-drawn wagon. Thus, the livery stable was an important place in early Enid. This is the livery stable of Frank Avery at 125 East Randolph Avenue. (Courtesy of Cherokee Strip Regional Heritage Center.)

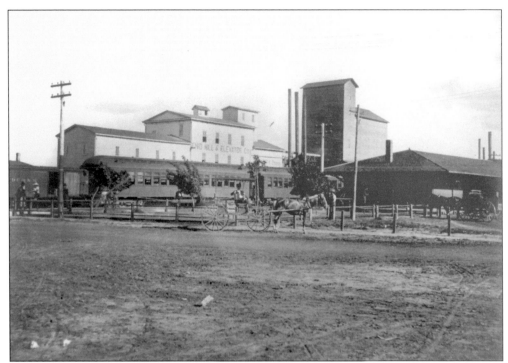

Enid became the center for four major railroad lines and several branch lines. In 1911, Garfield County had railroads valued at $5.7 million, ranking No. 4 in the state. This is the depot for the Chicago, Rock Island & Pacific Railroad, known as the Rock Island. This is the earlier depot, which was located in the same place as the later one, at what was then Market Street, now Owen K. Garriott Road. (Courtesy of Cherokee Strip Regional Heritage Center.)

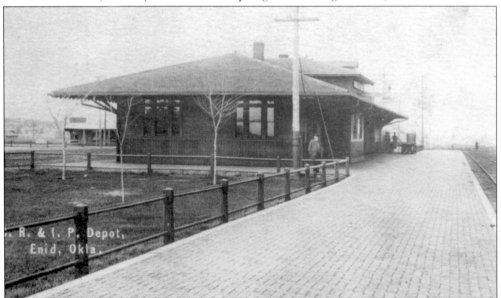

Here is another picture of the Rock Island Depot from another angle. This line stretched from Kansas in the north through to Texas in the south. It was the first one built through Enid, completed by the fall of 1889. (Courtesy of Archives Division, Oklahoma Historical Society.)

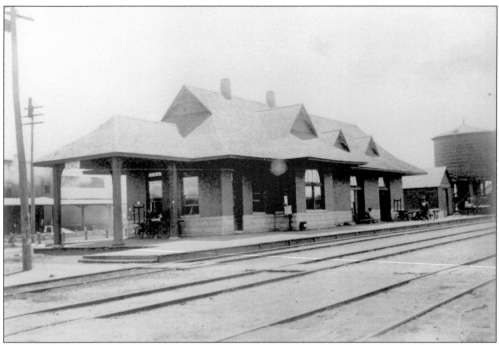

The San Francisco & St. Louis, called the Frisco, also came through Enid. Pictured is its depot. (Courtesy of Cherokee Strip Regional Heritage Center.)

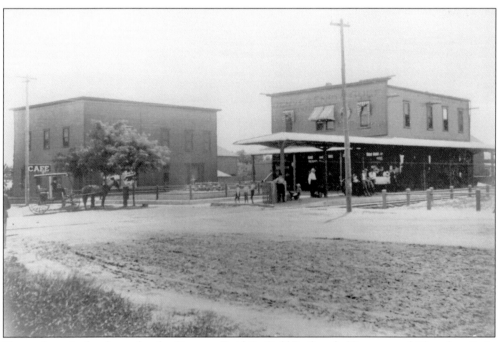

Shown here is the depot for the Denver, Enid & Gulf Railroad. (Courtesy of Cherokee Strip Regional Heritage Center.)

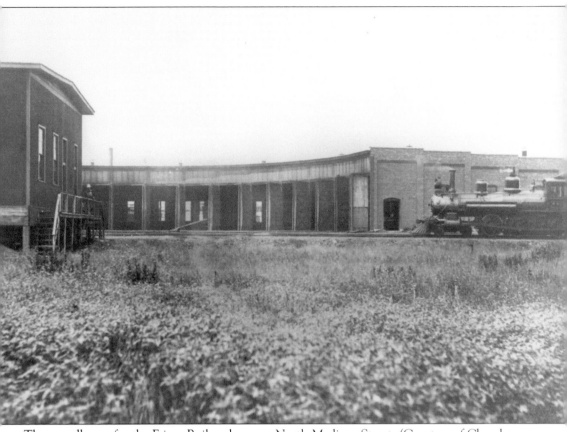

The roundhouse for the Frisco Railroad was on North Madison Street. (Courtesy of Cherokee Strip Regional Heritage Center.)

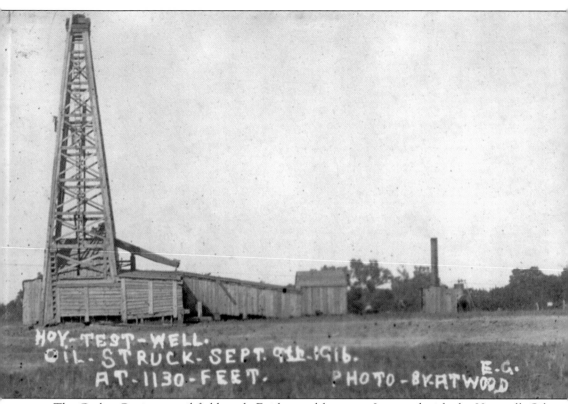

The Garber-Covington oil field made Enid a wealthy town. It started with the Hoy well. Oil was struck at 1,130 feet on September 9, 1916, and became a gusher on September 10. The large wooden building to the side of the well housed the pump, which pulled the drill of the well itself. (Courtesy of Cherokee Strip Regional Heritage Center.)

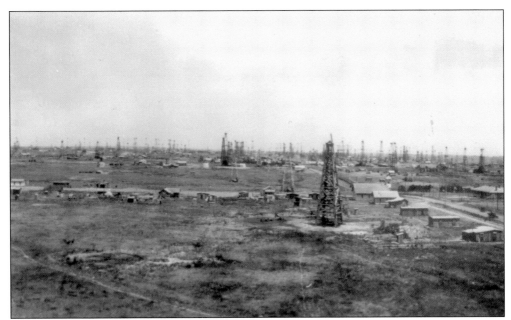

The oil field was in an area roughly halfway between Garber and Covington, some 20 miles east of Enid. Drillers discovered oil bearing sands at various intervals underground almost like layers of a cake. Garber-Covington made the fortune of many men, including H.H. Champlin and J. Paul Getty. (Courtesy of Cherokee Strip Regional Heritage Center.)

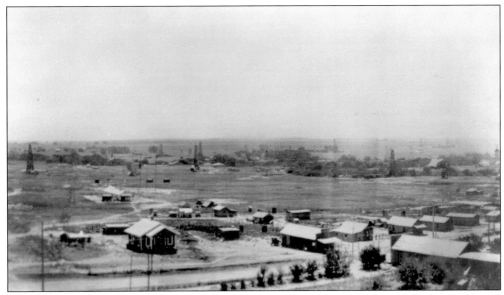

This photograph is another portion of the previous picture, showing some of the houses the oil workers and their families lived in. The author's grandfather, John Leslie Jones, worked in this oil field for a time. (Courtesy of Cherokee Strip Regional Heritage Center.)

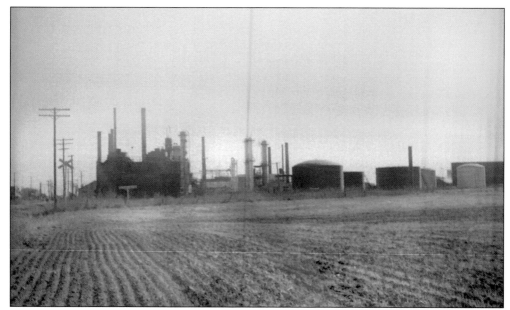

The Champlin Refinery was started in 1917 by H.H. Champlin and produced 300 barrels a day. The first service station started on East Broadway in 1921. When the refinery closed in 1984, it was producing 55,000 barrels a day. Here is the refinery on October 10, 1940. (Courtesy of Archives Division, Oklahoma Historical Society.)

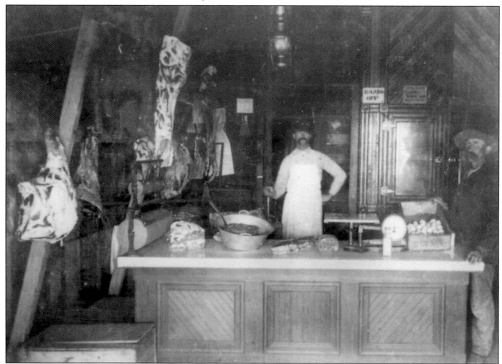

In the town of Enid, there were naturally many stores dealing with the various needs of the town. Pictured is a meat market. The men are Jim Gift (left) and Pete Sheen. (Courtesy of Cherokee Strip Regional Heritage Center.)

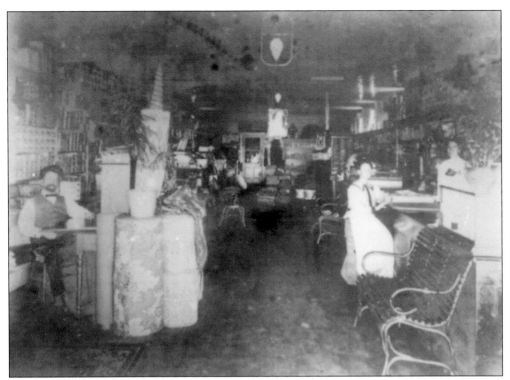

This is an interior of Evans Drug at 103 North Grand Avenue in 1910. Samuel B. and Charles S. Evans were the pharmacists at that time. (Courtesy of Cherokee Strip Regional Heritage Center.)

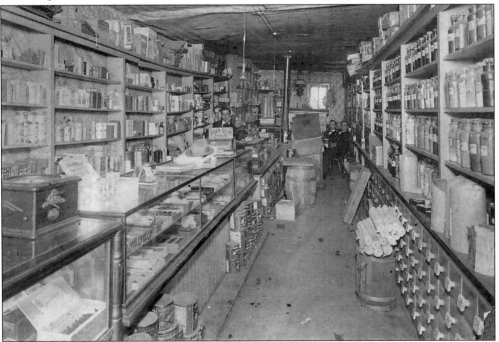

Here is another picture of Evans Drug in 1897. (Courtesy of Cherokee Strip Regional Heritage Center.)

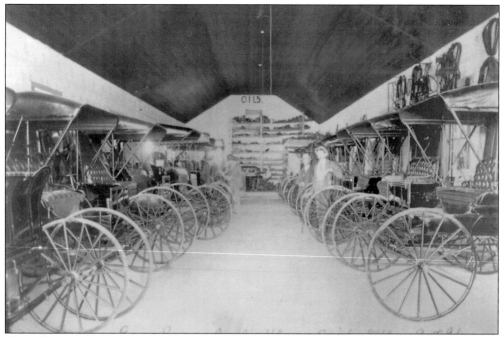

Shown here is the interior of the buggy room of Cowles Hardware Company on East Broadway sometime between 1900 and 1903. (Courtesy of Cherokee Strip Regional Heritage Center.)

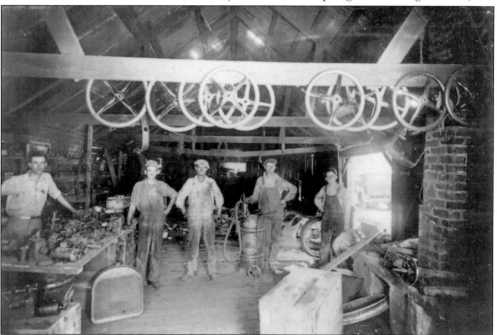

Later, everyone wanted cars, and even Enid got into the act of making them. The Geronimo Automobile factory was located at the intersection of Cleveland Street and Oklahoma Avenue in Enid from 1916 until 1920, when a fire burned it to the ground. Here is the machine shop of that factory. Today, only one Geronimo automobile survives, owned by the Enid Antique Auto Club. (Courtesy of Cherokee Strip Regional Heritage Center.)

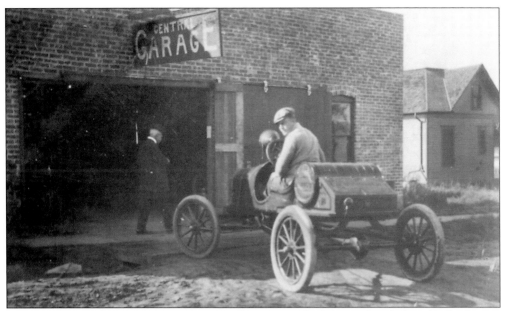

The George E. Failing Company was a major business in Enid. It was founded in 1931 by George E. Failing and originally made a name for itself with portable rigs that drilled water wells. Later, these were adapted to drill for oil. Pictured is the central garage. (Courtesy of Cherokee Strip Regional Heritage Center.)

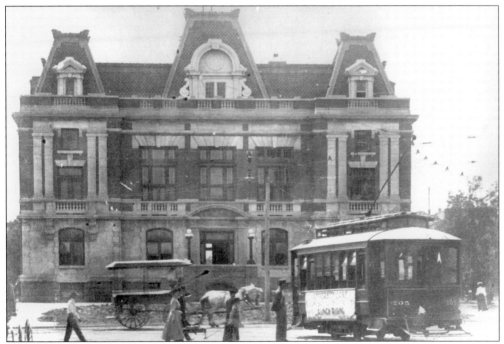

Though streetcar rates had originally been 5¢, they were raised to 7¢ in December 1918. This picture was taken after 1907 as the second courthouse is prominent in the picture. (Courtesy of Cherokee Strip Regional Heritage Center.)

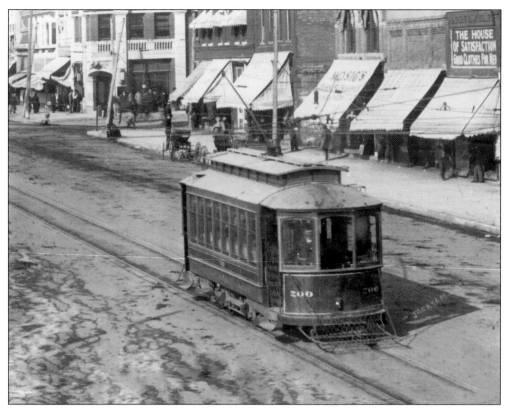

The increased use of automobiles in Enid caused the city council to pass an ordinance outlawing the entire streetcar system on August 29, 1929. By September of that year, busses were already in operation in Enid. (Courtesy of Cherokee Strip Regional Heritage Center.)

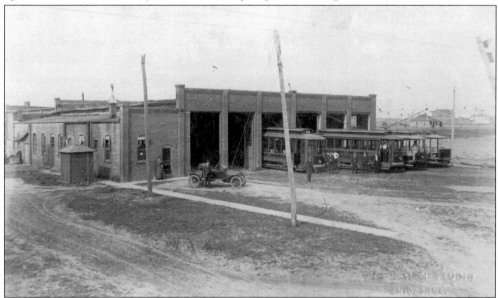

This is the storage barn for the streetcars at 2200 West Oklahoma Avenue. (Courtesy of Cherokee Strip Regional Heritage Center.)

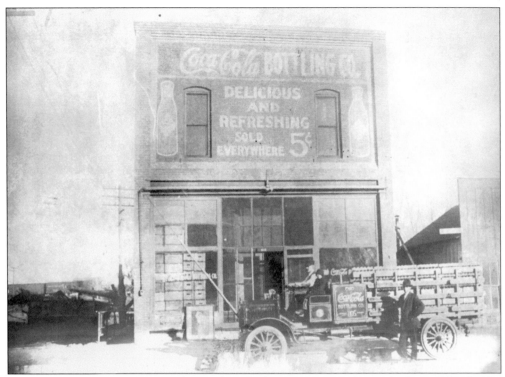

Even brands that people consider modern had an impact in the early days of Enid. The Coca-Cola office stood at 401 South Grand Avenue. (Courtesy of Cherokee Strip Regional Heritage Center.)

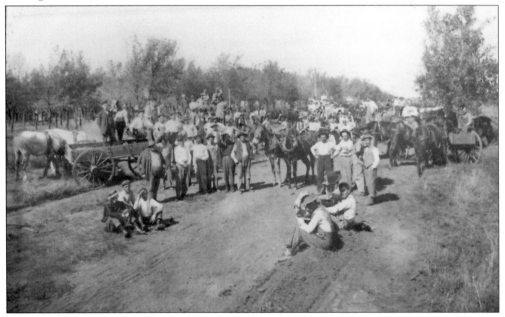

With the importance of the automobile came the need for more roads. Pictured here is a road-building crew. The date is uncertain but may be in the early 1920s. (Courtesy of Cherokee Strip Regional Heritage Center.)

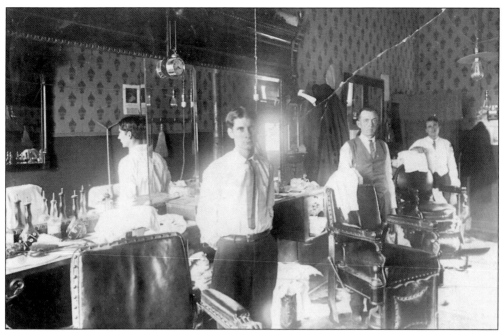

Barbershops were an important social center. This is the barbershop of L.W. (Lott) Lucas at 132 West Randolph Avenue in 1907. (Courtesy of Cherokee Strip Regional Heritage Center.)

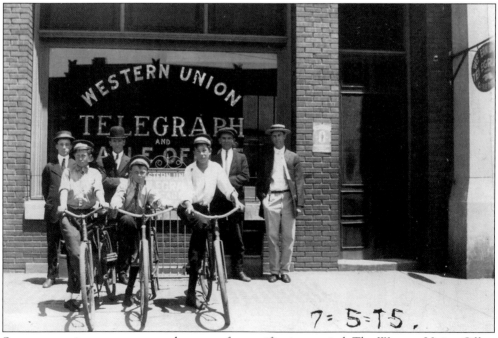

Some occupations were very much a part of a specific time period. The Western Union Office sat at 110 East Broadway with A.T. Semrad as manager. Here, some young boys get ready to deliver Western Union telegrams on July 5, 1915. (Courtesy of Archives Division, Oklahoma Historical Society.)

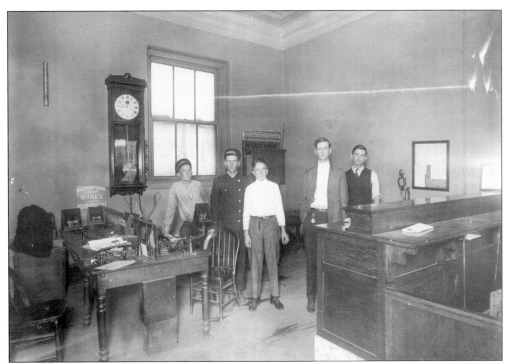

Pictured is the interior view of the Western Union Office around 1915. (Courtesy of Archives Division, Oklahoma Historical Society.)

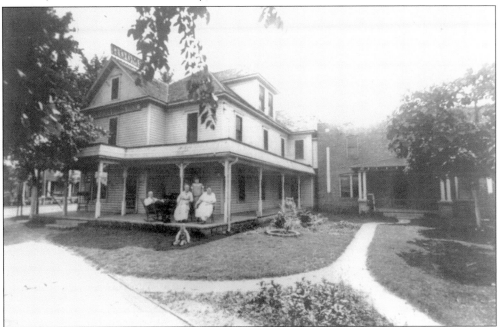

Oftentimes, boardinghouses provided income for many people. Here is the Rock Island Rooming House in 1910 with C.M. Connelly as proprietor. It was located at 724 South Grand Avenue, and its telephone number was 816. C.M. Connelly is maybe pictured in the rocking chair on the porch. (Courtesy of Cherokee Strip Regional Heritage Center.)

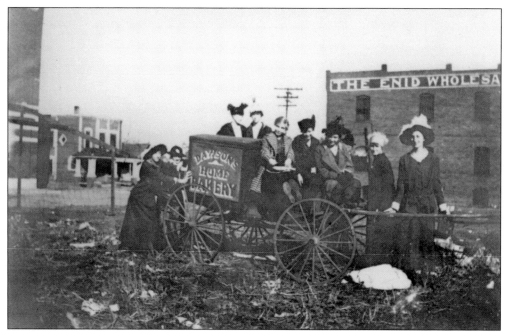

These enterprising young women appear to be affiliated with Dayson's Home Bakery. They also appear to be stuck. (Courtesy of Cherokee Strip Regional Heritage Center.)

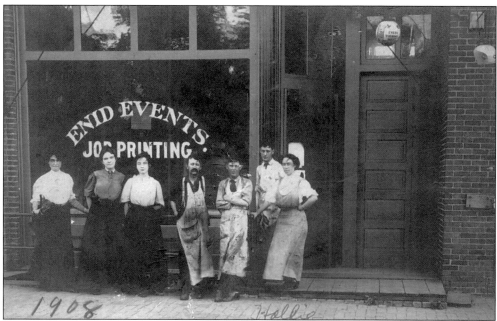

The first Enid newspaper was the *West Side Weekly Democrat*, published on September 19, 1893. *Enid Events*, with F. Everett Purcell as publisher, was located at 221 South Grand Avenue. It was a weekly newspaper that started as *Coming Events* in 1893 and became *Enid Events* in November 1899 and lasted until 1954. Unfortunately, only one person is identified in this group. Her name is given as Hallie. (Courtesy of Cherokee Strip Regional Heritage Center.)

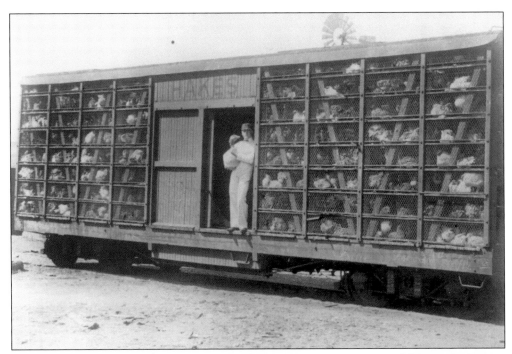

Raising chickens was once big business in Enid, though the bird that the man is holding at the door of the freight car looks more like a turkey. (Courtesy of Cherokee Strip Regional Heritage Center.)

TO THE

Big Show

AT

ENID, OKLA.

DECEMBER 9-16, 1912

Liberal Prizes
Attractive Exhibits

BIG CENTER POULTRY & PET STOCK ASS'N.

C. L. BARRICK, Sec'y.

From 1904 to 1914, raising poultry was the largest money producer in Enid. (Author's collection.)

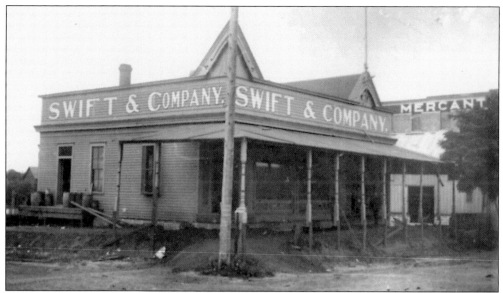

In 1928, Enid's Swift and Company led the nation in poultry production and was the second largest in the world. Its office was at 301 South Grand Avenue. (Courtesy of Cherokee Strip Regional Heritage Center.)

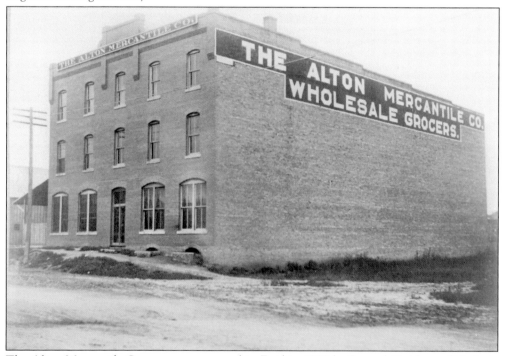

The Alton Mercantile Company was opened in Enid in 1902 by Samuel T. Alton of Keokuk, Iowa. Though famous for making brooms, it sold many other items. The product line included candy, cocoa, pancake flour, coffee extracts, tea, spices, canned fruits and vegetables, canned oysters, chocolate, raisins, olive oil, pickles, macaroni, gelatin, vinegar, rice soda, powdered sugar, corn starch, tapioca, syrup, soap,, and much more. (Courtesy of Cherokee Strip Regional Heritage Center.)

Electricity came to Enid in 1899 when an amusement company needed current to operate its rides and light the midway. In 1902, the small plant the amusement company built was purchased by H.M. Byllesby and Company and named the Enid Gas and Electric Company. These two men are driving a cart with the company's name on it. One of these two is George F. Southwick. (Courtesy of Cherokee Strip Regional Heritage Center.)

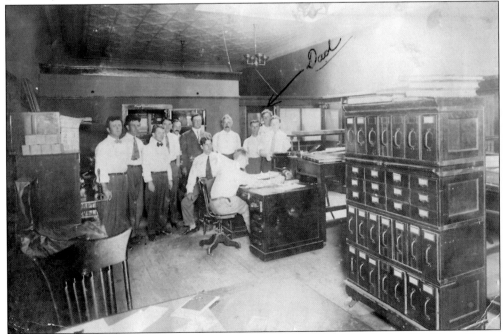

This is the office of the Enid Gas and Electric Company. The man marked as "Dad" was George F. Southwick, who was a lineman for the company. (Courtesy of Cherokee Strip Regional Heritage Center.)

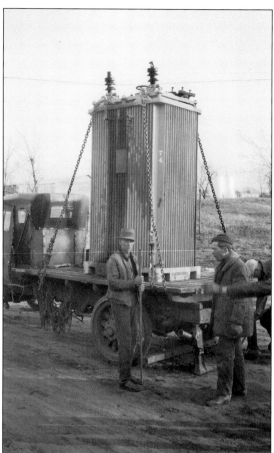

Naturally, this particular industry did not stay small for long. Here, some men are transporting a fairly large transformer on an OG&E (Oklahoma, Gas & Electric Company) truck in the Enid area sometime between 1925 and 1927. (Courtesy of Archives Division, Oklahoma Historical Society.)

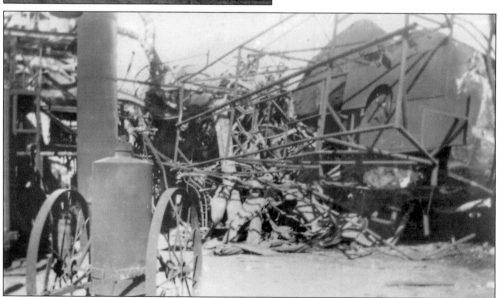

Occasionally, things would go wrong. This is a photograph of the aftermath of a disaster at the Eason Oil Refinery in 1938. (Courtesy of Cherokee Strip Regional Heritage Center.)

The Enid Fire Department started March 20, 1902. It was a two-man department, consisting of Chief Ike Ostendorf (the driver of the wagon) and his assistant, Homer Osborn. Both men were paid $45 a month. The other men by the wagon were policemen. Unfortunately, only the man with the cane, police judge Jake Roach, is identified. (Courtesy of Cherokee Strip Regional Heritage Center.)

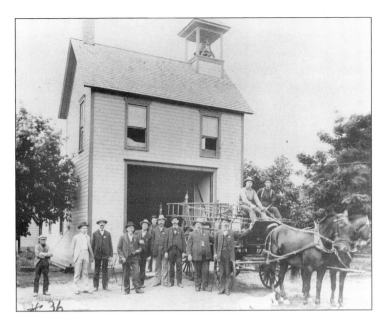

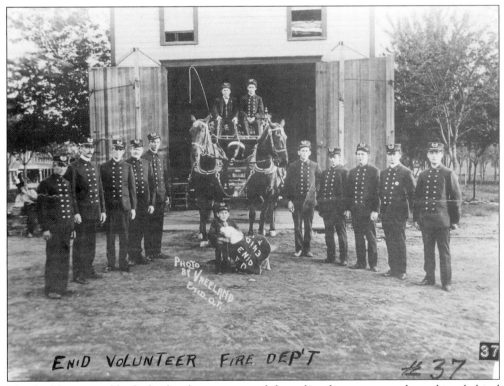

This building served both the fire department and the police department and stood just behind the present-day Cherokee Strip Conference Center on Independence Street. Here is a formal portrait, sadly without names. (Courtesy of Cherokee Strip Regional Heritage Center.)

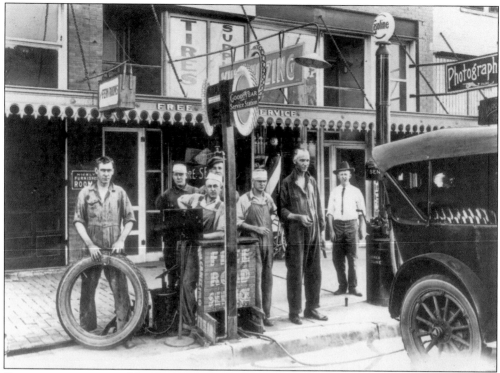

Soon, garages, as some of the more important places in town, replaced the livery stable. (Courtesy of Archives Division, Oklahoma Historical Society.)

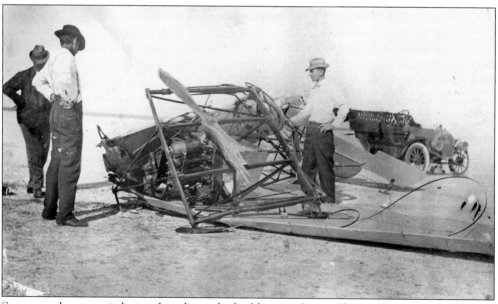

Some people even tried to make a living by building airplanes. This is Clyde Cessna, the first Oklahoman to fly, just after his monoplane crashed. The postcard is postmarked "September 1911, Jet, Oklahoma." (For more information on Clyde Cessna, see chapter 5.) (Courtesy of Archives Division, Oklahoma Historical Society.)

Four

SCHOOLS, CHURCHES, AND HOSPITALS

Enid, like other booming towns of the period, wanted to have a good system of education for its children. From the humble start of a tent subscription school, Enid developed a system of grade schools in different wards of the city as well as a major high school built in 1912, which, with modifications, continues to this day.

A major asset of Enid started at the very beginning. Enid Business College was founded in 1894 and continued for over 70 years, becoming especially important in the late 1940s and 1950s.

Enid business leaders were determined from the start to have a college in their town and succeeded in 1907 in founding Oklahoma Christian University, which became Phillips University in 1912. Phillips served as a major institution of higher learning for Enid and northwest Oklahoma for almost 90 years.

Supposedly, the first sermon preached in Enid after the run was by a Presbyterian minister, preaching from the back of a wagon. However, an Episcopalian bishop and a Methodist claim to have preached from wagons the next day. The first Catholic Mass in Enid was in March 1894, and by 1910, a small Jewish meeting group existed as well. The Disciples of Christ denomination has long been very numerous in Enid because of its association with Phillips University. Presbyterians, Methodists, Catholics, Baptists, and Congregationalists all built substantial churches, which served the religious needs of early-day Enid. Some of these churches grew and flourished, and some did not.

Enid was also blessed from the early days with good hospitals. The first hospital was University Hospital, founded in 1907 by Dr. S.N. Mayberry. Many of the Phillips faculty lectured to the nursing students. Present-day St. Mary's was started as the Enid Springs Sanitarium and Bathhouse in 1914 by Dr. G.A. Boyle. The precursor to Bass Baptist Hospital was Enid General Hospital, which started in 1910 in a residence on Oak Avenue and then moved to a larger house on Pine Avenue in 1911.

All of these institutions are testimonials to the work the people of Enid undertook to make of their town a major city.

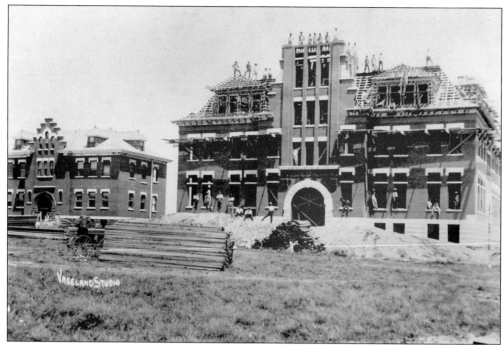

In 1907, Enid founded a four-year university originally called Oklahoma Christian University. In 1912, the name was changed to honor T.W. Phillips, a donor to the school who lived in Butler, Pennsylvania. Phillips University was a major force in education in northwest Oklahoma for almost 90 years. Here, the school's main buildings are under construction. (Courtesy of Cherokee Strip Regional Heritage Center.)

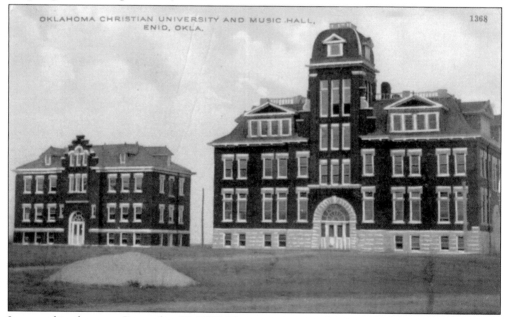

It opened its doors on September 17, 1907. Here, one can see the major buildings after they were finished. The larger building was the main administration building. Sadly, it burned to the ground in 1947. (Author's collection.)

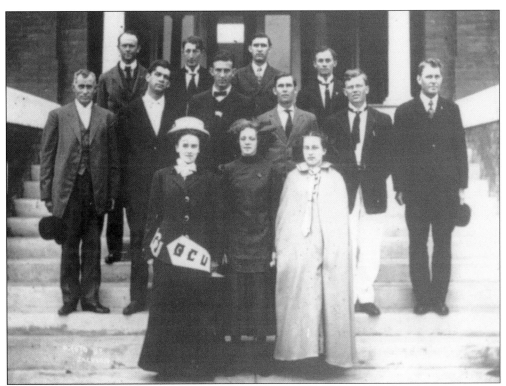

This is a photograph of a freshman class at Phillips, taken sometime before 1912 as the pennant says "OCU" for Oklahoma Christian University, Phillips's original name. Unfortunately, the names of the students are not known. (Courtesy of Cherokee Strip Regional Heritage Center.)

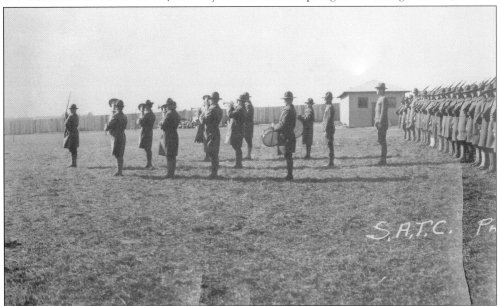

Many of the men at Phillips, as elsewhere in the country, were anxious to be a part of World War I. This is a photograph of the Student Army Training Corp at Phillips in 1917 or 1918. (Courtesy of Cherokee Strip Regional Training Center, Enid.)

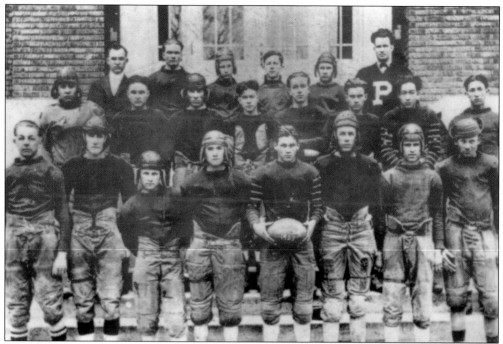

This picture is labeled "Phillips University High School Football team—1923"; members of the team were called Junior Haymakers. Pictured and listed in no particular order are J. Davis, ? Keith, ? Geil, Captain Weaver, J. Denker, ? Ballard, F. Denker, ? Pulver, ? Horner, ? Zedler, M. Davis, ? Williams, ? Claytor, and ? Brown. (Courtesy of Cherokee Strip Regional Heritage Center.)

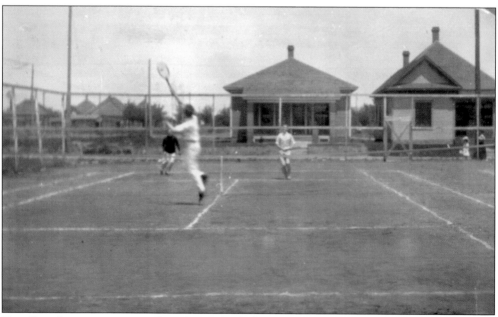

Not all students were interested in playing football. Here are some men playing tennis. (Courtesy of Cherokee Strip Regional Heritage Center.)

Enid was a large enough town that it needed several grade schools. Pictured is Kenwood Elementary at 602 West Elm Street, which was in operation by 1902. The students appear to have been drawn onto the picture. (Courtesy of Cherokee Strip Regional Heritage Center.)

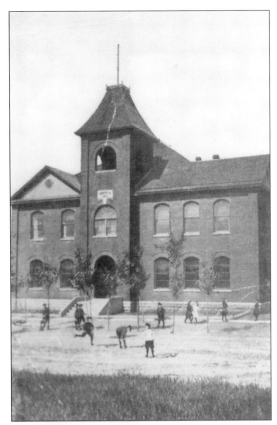

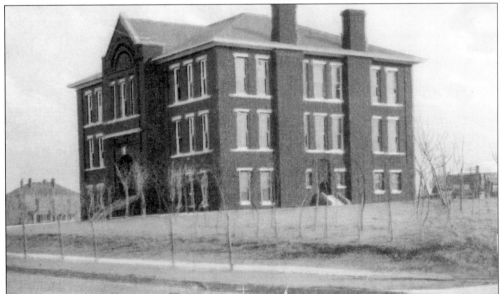

Constructed in 1906, this is Enid's first high school building on North Independence Street. In 1912, the new high school building was erected on West Wabash Avenue where it remains today. This building then became Lincoln Grade School. It was incorrect to refer to it as Lincoln High School. (Author's collection.)

Here is a photograph of Jefferson School in Enid. The eight-room brick building was erected in 1908 at 200 West Market Street (now Owen K. Garriott Road). A new building was opened in 1926. In 1973, this building was remodeled and became the center for food services for Enid's elementary schools. (Courtesy of Archives Division, Oklahoma Historical Society.)

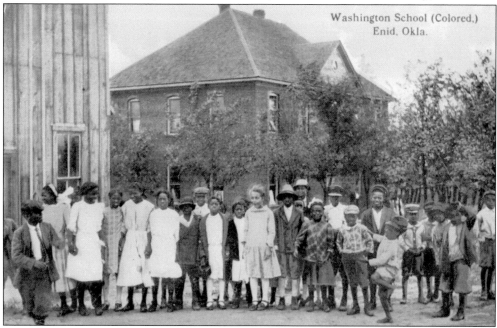

Unfortunately, segregation came early to Enid. A tent school for black children was started in 1894 at Fifth and E Streets. W.J. Johnson was its first teacher. In 1896, Booker T. Washington School was organized in a small frame building at Oklahoma Avenue and Seventh Street. There was a nicer school constructed in 1901, which may be the building in this photograph. (Courtesy of Cherokee Strip Regional Heritage Center.)

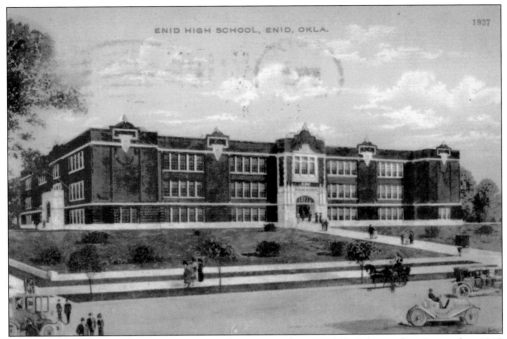

The newer, larger high school was opened for use in February 1912. It burned in September 1943 but was rebuilt and, with major modifications, still serves Enid today. (Courtesy of Cherokee Strip Regional Heritage Center.)

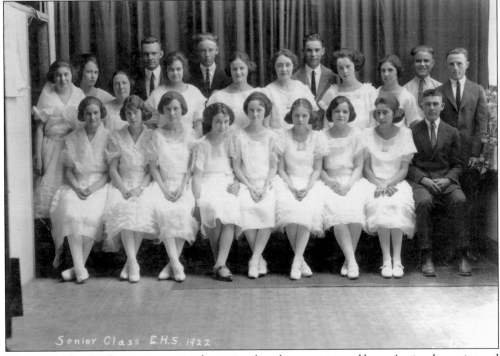

Senior Class E.H.S. 1922

The annual for 1922 lists more men in the senior class than are pictured here. Again, those pictured are unidentified. (Courtesy of Archives Division, Oklahoma Historical Society.)

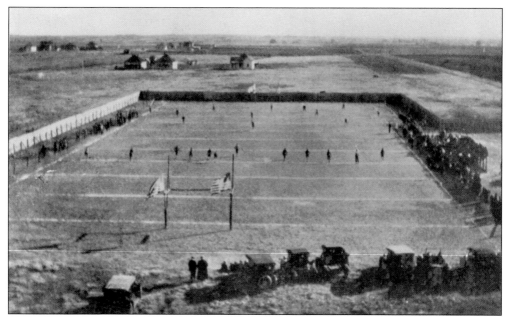

Today, football is an important part of the life of Oklahoma. Probably close to where it is today just off Van Buren Avenue, this is an earlier football field for Enid High. (Courtesy of Cherokee Strip Regional Heritage Center.)

The Enid Business College provided what is known today as vocational technical education. It was started in September 1894 by W.N. Stephenson and was originally located on the west side of the square. Around 1900, it was on the second floor above the Red Dog Saloon. This photograph shows its location at 213 North Grand Avenue, which was where it moved to in the 1920s. Over its 75-year history, some 20,000 to 25,000 students attended the school. (Courtesy of Cherokee Strip Regional Heritage Center.)

Pictured is a graduating class from the Enid Business College, with only two people identified. Eva Campbell is sitting on the far right in the first row, and Zo Muggon is third from the left in the third row. (Courtesy of Archives Division, Oklahoma Historical Society.)

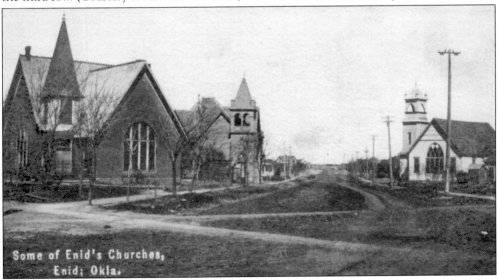

Some of Enid's Churches, Enid; Okla.

Religion has always been an important part of life for Enid citizens. This photograph, taken about 1907, is looking west in an area called Five Corners, which included Randolph Avenue, Kenwood Boulevard, and Washington Avenue. It was called Five Corners because of the extra street that intersected with the others. On the left is the earliest First Presbyterian Church. In the center is the Congregational church, and on the right is the Baptist church. (Courtesy of Archives Division, Oklahoma Historical Society.)

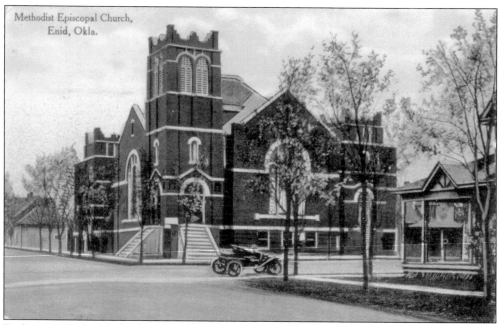

Built in 1910, the Methodist church is pictured at the corner of West Randolph Avenue and North Adams Street. (Author's collection.)

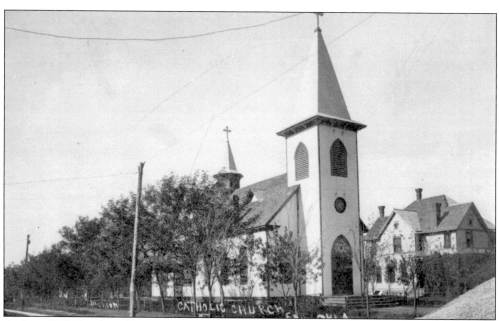

At first, Catholics heard Mass in private homes, but after 1897, Father Depreitere of Hennessey held Mass in a small frame building on the south side of the square. Soon, fundraising for a new church began. On May 1, 1900, Bishop Theophile Meerschaert dedicated the new church dedicated to St. Francis Xavier. (Courtesy of Cherokee Strip Regional Heritage Center.)

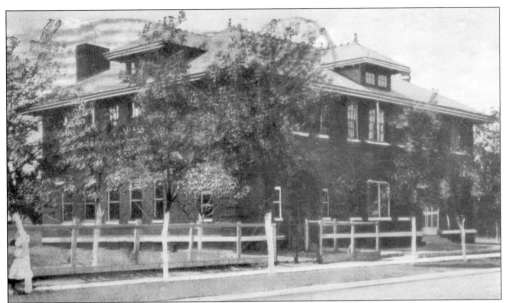

The nine-room brick structure of St. Joseph's Catholic School, sometimes called St. Joseph's Institute, was dedicated in 1904. The school system had been operating for several years without a permanent home, graduating six students at its second commencement in 1899. This was the predecessor of Memorial High School. (Author's collection.)

This photograph is labeled "Last Christmas in the Old Baptist Church." The first Baptist Church moved into its initial permanent location in December 1898. It was at the corner of Broadway and Washington Avenue, which is most likely the church pictured above. The congregation moved into a bigger structure in 1909 at 401 West Maine Street. (Courtesy of Cherokee Strip Regional Heritage Center.)

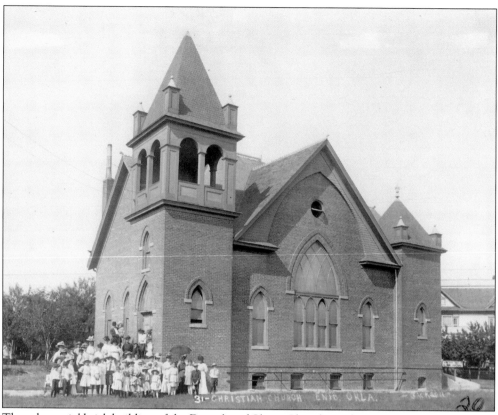

The substantial brick building of the Disciples of Christ Church was located at Adams Street and Kenwood Boulevard. This building was dedicated on November 29, 1903. (Courtesy of Cherokee Strip Regional Heritage Center.)

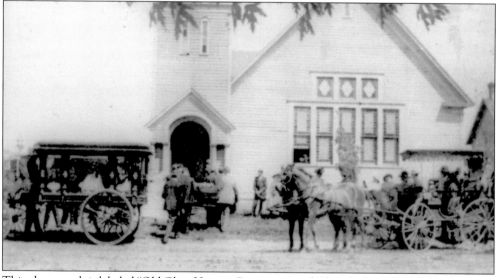

This photograph is labeled "Old Glass Hearse, Congregational Church, funeral of Wilford Pitman, 1903." In 1905, with only 40 members, the Congregational Church disbanded, with many joining the Presbyterians. (Courtesy of Cherokee Strip Regional Heritage Center.)

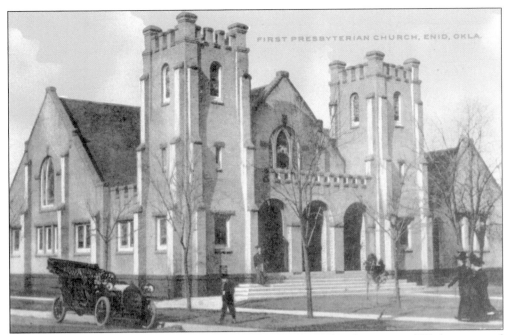

The original First Presbyterian Church, built in July 1894, stood at the corner of Washington and Randolph Avenues. It was replaced by this structure at the same location in 1907. The current church on West Maine Street was dedicated on November 13, 1927. (Courtesy of Archives Division, Oklahoma Historical Society.)

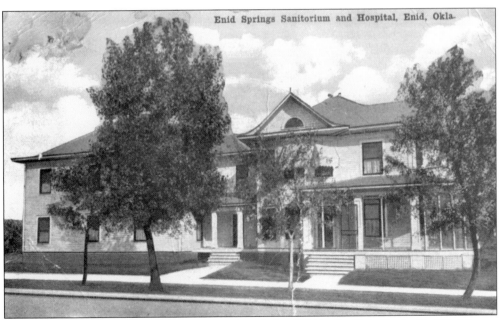

Enid Springs Sanitarium and Bathhouse was founded in 1914 by Dr. G.A. Boyle. Dr. T.B. Hinson later joined him and enlarged their hospital. In 1937, it was sold to the Sisters Adorers of the Most Precious Blood, who changed the name to St. Mary's Hospital. (Courtesy of Archives Division, Oklahoma Historical Society.)

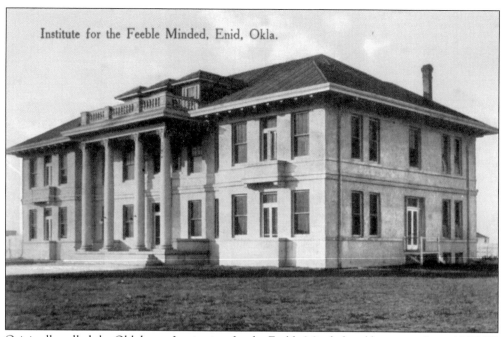

Institute for the Feeble Minded, Enid, Okla.

Originally called the Oklahoma Institution for the Feeble Minded and known today as NORCE (Northern Oklahoma Resource Center for Enid), this institution served those with mental handicaps. In 1909, the Oklahoma State Legislature appropriated $155,000 to construct this school, which lies in the northeast corner of Enid. Originally, W.L. Kendall, MD, who had a staff of 15, headed it. This central administration building still stands. (Author's collection.)

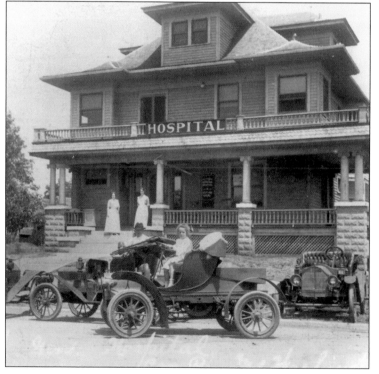

This house at 228 West Pine Avenue served as a hospital for Enid from 1911 until 1914, when the hospital moved to 401 East Broadway. In 1920, Laura Crews (see chapter 5) purchased the house and owned it until her death in 1976 at the age of 105. It stood at the corner of Pine and Washington Avenues, where the playground for the Salvation Army Day School is today. (Courtesy of Cherokee Strip Regional Heritage Center.)

Five

PEOPLE

Though most the people of Enid were heavily of Germanic and Czech background, many would simply have called themselves "Americans." African Americans made up about 10 percent of the population. There was a small, but prosperous, contingent of those with Jewish backgrounds, who also made a little congregation that met for a time in the Loewen Hotel.

Some, like Laura Crews, made the land run of 1893 and struck it rich. Though Aunt Laura never married, her house at 228 West Pine Avenue became a meeting place for her numerous nieces and nephews and for many people who called her "Aunt Laura" and were not related to her at all.

Marquis James came to Enid as a very small boy and never forgot. In his book *The Cherokee Strip, An Oklahoma Boyhood*, James paints an idyllic picture of an Enid that surely existed mostly in his creative imagination. James earned two Pulitzer Prizes for his biographies of Sam Houston and Andrew Jackson.

Some, like H.H. (Herbert Hiram) Champlin, founded enormously successful companies.

Many served their country, while others gave their lives for it. In various way, everyone has added to the tapestry that is Enid, Oklahoma.

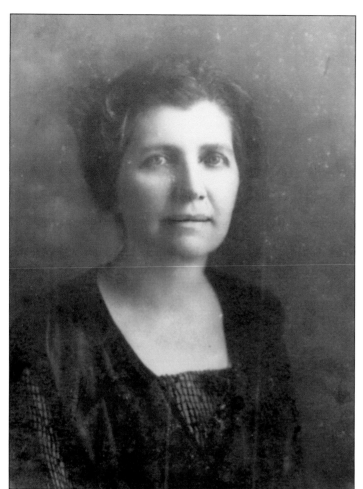

Laura Ella Crews (1871–1976) was the last of the Cherokee Strip pioneers to die at the age of 105. Laura made the land run from the south side of the Cherokee Strip wearing a skirt that was divided so she did not have to ride sidesaddle. She homesteaded halfway between Garber and Covington. Her farm proved to be on part of the Garber-Covington oil field. With this wealth, she moved to Enid (see chapter 4) and, though she never married, raised six foster children. Even to those not related to her, she was known as "Aunt Laura." (Courtesy of Cherokee Strip Regional Heritage Center.)

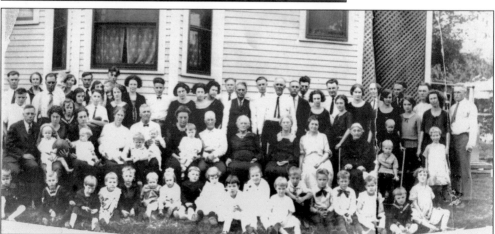

Her house at 228 West Pine Avenue became a center for family reunions. Laura was one of seven children, most of whom had children and grandchildren. This photograph was taken about 1925. Aunt Laura is in the right center in white among several older women in black. (Author's collection.)

Marquis James (1891–1955) was Enid's most famous author. He won the Pulitzer Prize twice, first in 1930 for his biography of Sam Houston and then again in 1938 for his two-volume biography of Andrew Jackson. His book *The Cherokee Strip, An Oklahoma Boyhood*, published in 1945, is full of reminiscences about Enid in his youth. (Courtesy of Cherokee Strip Regional Heritage Center.)

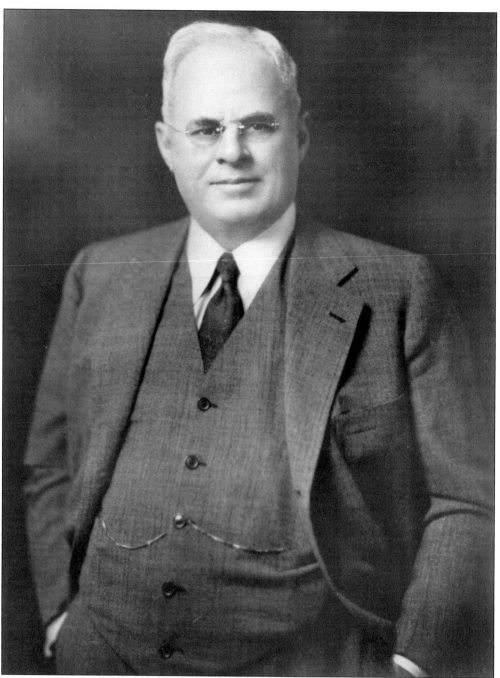

H.H. Champlin (1868–1944), one of six brothers, grew up in McPherson, Kansas. He went to Kingfisher in 1889 and started a lumberyard there. He came to Enid with the run and then started a lumberyard on the northeast corner of the square. He branched out into banking and later made a name for himself as the founder of the Champlin Oil Company. (Courtesy of Archives Division, Oklahoma Historical Society.)

The earliest doctors in Enid were called "the Big Four." They are, from left to right, (sitting) R.A. Feild (spelled "e" before "i") and M.A. Kelso; (standing) C.F. Champion and H.B. McKenzie. (Courtesy of Cherokee Strip Regional Heritage Center.)

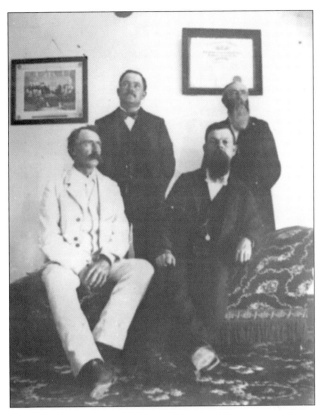

Born in 1879, Clyde Cessna came to Enid in 1908 to manage an auto dealership. He built his first plane in 1911. Though he finally got his planes to fly, he could not find enough money from Enid bankers to start a company. So, in 1913, he went to Kansas and later founded Cessna Aircraft Company in 1927, which is still one of the biggest industries in Wichita, Kansas. (Courtesy of Cherokee Strip Regional Heritage Center.)

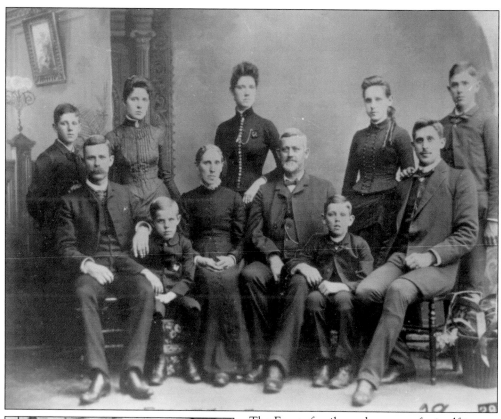

The Frantz family made a name for itself in Enid as well as Oklahoma as a whole. Those pictured are, from left to right, (sitting) William Douglas Frantz, Montgomery J. Frantz, Maria Gish Frantz, Henry Jackson Frantz, Orville Frantz, and Edmond Frantz; (standing) Walter Frantz, Minnie Frantz (Hieronymus), Lula Frantz (Whitson), Mamie Frantz (Rary), and Frank Frantz. Frank Frantz served as the last territorial governor of Oklahoma from January 15, 1906 to November 16, 1907. (Courtesy of Cherokee Strip Regional Heritage Center.)

On January 13, 1903, a man named David E. George lay dying in an upstairs room over what is now Garfield Furniture. On his deathbed, he claimed to be John Wilkes Booth, assassin of Abraham Lincoln. After death, his unclaimed body was on display in a local funeral home. Later, it was sold to a circus and subsequently disappeared. This photograph shows the body on display. (Courtesy of Cherokee Strip Regional Heritage Center.)

Enid men have always been very patriotic. This is Ralph
Beaumont Hesser (1893–1978), who served in World War I.
(Courtesy of Cherokee Strip Regional Heritage Center.)

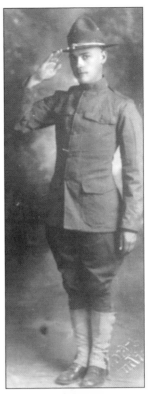

On July 4, 1924, the DAR (Daughters of the American
Revolution) erected a statue to the doughboys of World War
I. From left to right are Mrs. J.S. (Martha) Reger, Mrs. John
(Harriette) Curran, Maurine Frantz, Mrs. O.J. (Ella) Fleming,
Mrs. John (Nancy) Clover, Lola Durst, Mrs. I.N. (Marietta)
McCash, Mrs. Everett (Pearl E.) Purcell, Mrs. Edwin (Grace)
Frantz, Mrs. W.H. Scaeff, Mrs. Frank (Clara) Letson, Mrs. Carl
(Clara) Kruse, Mrs. P.A. (Kittie) Smithe, Mina Admire Chattam
with her daughter Ione in front of her, and Cora Case Porter.
(Courtesy of Cherokee Strip Regional Heritage Center.)

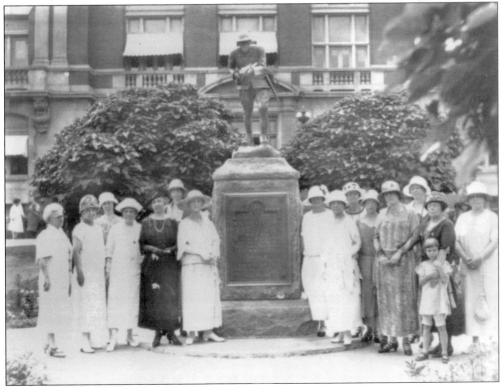

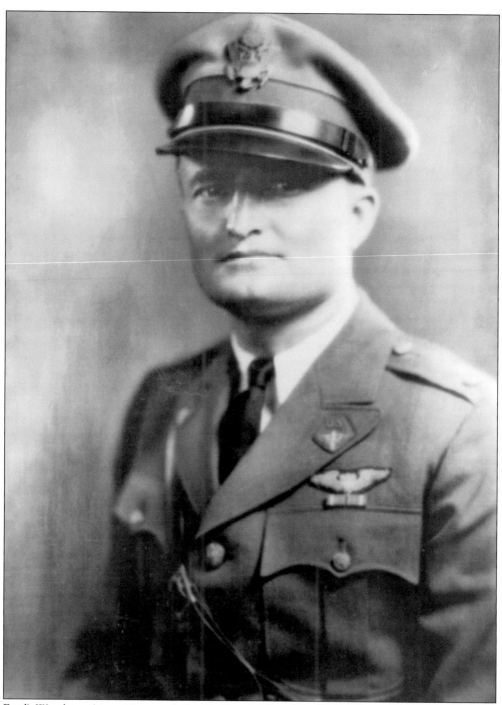

Enid's Woodring Airport is named after Enid native Bert Woodring, who made a name for himself as a pilot. He was part of a group of stunt pilots known as the Three Musketeers, all of whom died in airplane crashes. Woodring was the last of the group to die in 1933. (Courtesy of Cherokee Strip Regional Heritage Center.)

This 1925 photograph is of H.H. Champlin's nephew, Ens. Jackson Champlin (1904–1988), and was taken probably on his graduation from the Naval Academy. Though the ship he was on in Pearl Harbor, the USS Colorado, was sunk, he survived and was awarded a Bronze Star. He became a rear admiral. (Courtesy of Cherokee Strip Regional Heritage Center.)

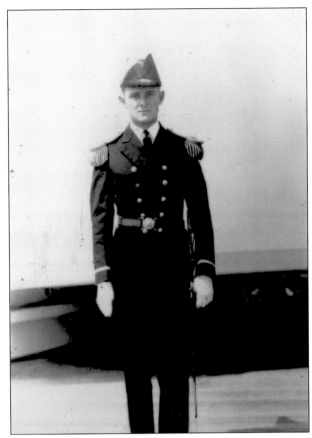

Pictured is then lieutenant Jackson Champlin on leave from the Pacific fleet for a visit to Enid in July 1935. From left to right, the men are his father, Fred C. Champlin; Jackson Champlin; Ralph May; James H. Van Zant; and his brother Frederick C. Champlin. The women are, from left to right, his wife, Betty Troutner Champlin; his sisters Ruth Champlin Van Zant and Dorothy Champlin May; and his mother, Louise Selover Champlin. (Courtesy of Cherokee Strip Regional Heritage Center.)

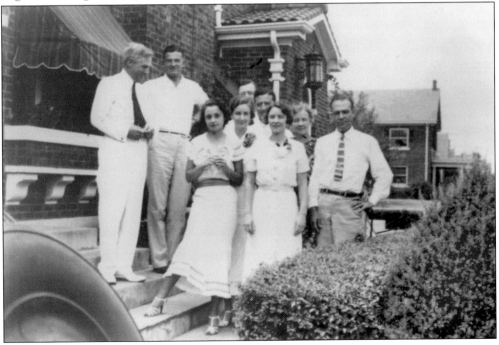

Lt. Col. Leon Robert "Bob" Vance Jr. (1916–1944) flew bombing missions during World War II and survived ditching his bomber in the English Channel. Severely wounded, he was returning to America in July 1944 when his medical transport plane was lost in the Atlantic Ocean. He was posthumously awarded the Congressional Medal of Honor in 1946, and the award was presented to his three-and-a-half-year-old daughter Sharon. On July 9, 1949, Vance Air Force Base was named for him. (Courtesy of Cherokee Strip Regional Heritage Center.)

These unidentified ladies were members of what was called the Merry Hearts Society. They are enjoying a sunny afternoon next to a bandstand, perhaps in the center of town. (Courtesy of Cherokee Strip Regional Heritage Center.)

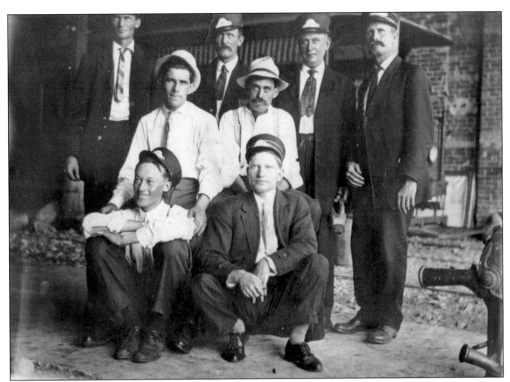

These unidentified men worked for the Enid Streetcar System. (Courtesy of Cherokee Strip Regional Heritage Center.)

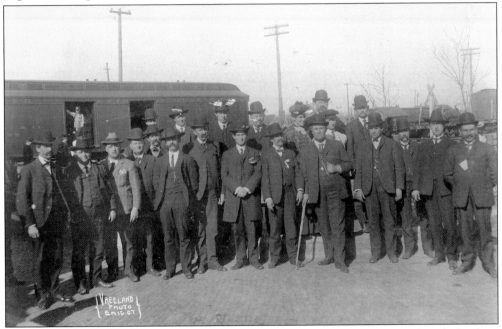

This group of men, except for the two ladies in the center of the second row, is identified only as a group of Oklahoma newspaper editors in Enid on May 20, 1910. (Courtesy of Archives Division, Oklahoma Historical Society.)

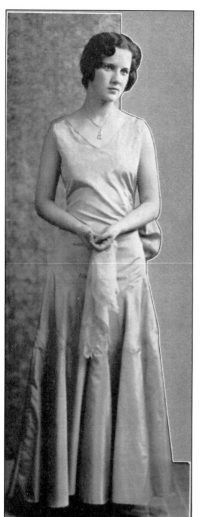

With men and women of Enid High School parading in their finest clothes and dancing around a maypole, the May Fete was celebrated in Government Springs Park. The first May Fete was held in 1915 with Faye Orelup as May queen. The then senior class president Henry B. Bass had the honor of placing the crown on Orelup's head. This ancient ritual continues today. Pictured is Miriam Buxton, the May queen for 1931. (Courtesy of Cherokee Strip Regional Heritage Center.)

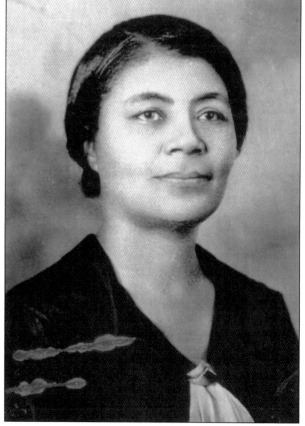

Mary Harris Umstead was the wife of Lewis J. Umstead, one of the premier black educators of Enid. Lewis J. Umstead was the principal of Booker T. Washington School from 1920 to 1925. In 1941, he organized the Enid branch of the NAACP (National Association for the Advancement of Colored People). They lived in a large American Foursquare–style house at 222 East Park Street in Enid. (Courtesy of Archives Division, Oklahoma Historical Society.)

Six

TRIUMPHS AND TRIALS

The years 1929 to 1945 provided Enid with many triumphs and many trials. New skyscrapers were built, while an old courthouse burned to the ground. With the construction of the new courthouse in 1934, Broadway was opened through the square, which it had not been before. In 1940, a new post office was constructed, which, after major renovations, still serves today.

The Garber-Covington oil field continued to pump money into Enid's economy, allowing some large new homes to be built. Major national department stores, like Montgomery Ward, built stores on the square, and downtown began to resemble what can be seen today.

One of the most famous incidents in Depression-era Oklahoma history happened on March 4, 1933, when Oklahoma governor William H. "Alfalfa Bill" Murray declared a state bank holiday to coincide with a federal bank holiday declared by the new president of the United States, Franklin Delano Roosevelt. The owner of Enid's First National Bank, H.H. Champlin, refused to close the bank. Governor Murray then called out the National Guard to close the bank.

Though the Great Depression did not hit Enid as hard as other places in America, the WPA (Works Progress Administration) and the federal government provided some relief with work projects that improved the town.

World War II affected all parts of the country, and Enid was no exception. South of town the Army started a training school for the Army Air Corp. This later became Enid Army Air Field and then Vance Air Force Base, one of the major institutions in present-day Enid.

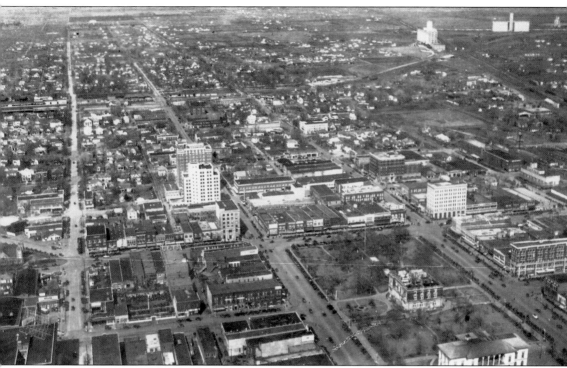

This bird's-eye view of Enid shows it around 1931, which is confirmed with the completion of the Broadway Tower at far right. The old courthouse still stands in the center of the square, though the picture seems to have been taken after it burned, as its signature Second Empire–style roof is no longer visible. There also seems to be smoke stains on the post office across the street. (Courtesy of Archives Division, Oklahoma Historical Society.)

Looking west on Broadway, this photograph is of the 14-story Broadway Tower under construction in 1929. (Courtesy of Cherokee Strip Regional Heritage Center.)

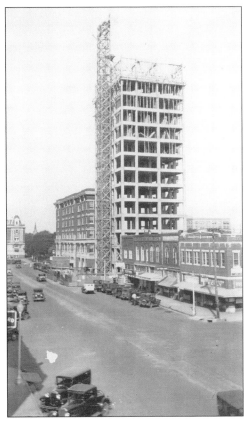

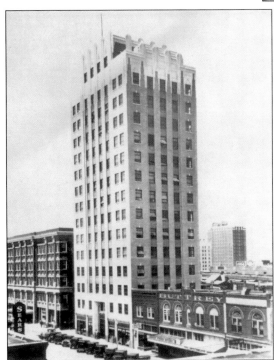

The tower was completed in May 1931. For its opening, William J. Otjen and H.G. McKeever addressed the crowd with Harry O. Glasser serving as master of ceremonies. (Courtesy of Cherokee Strip Regional Heritage Center.)

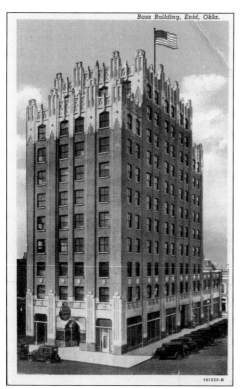

Bass Building, Enid, Okla.

Shown here is the 11-story Bass Building in the spring of 1930. It competed with the Broadway Tower to provide office space for Enid, and for a time, neither were fully occupied. (Courtesy of Archives Division, Oklahoma Historical Society.)

The second courthouse building of Garfield County burned on January 29, 1931. The Enid Fire Department undertook a major effort to try to save the building with nine firemen sent in response as well as pumper wagons Nos. 3 and 4, aerial wagon No. 1, and service wagon No. 9. The loss of the contents was valued at $72,360. (Courtesy of Cherokee Strip Regional Heritage Center.)

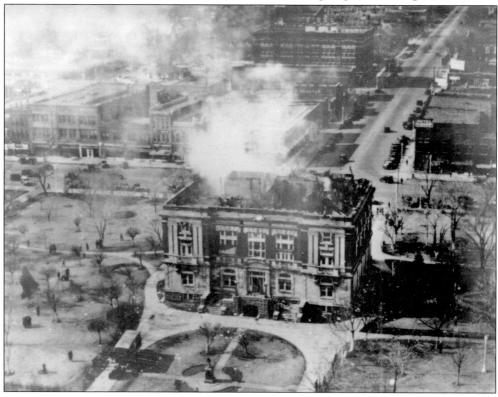

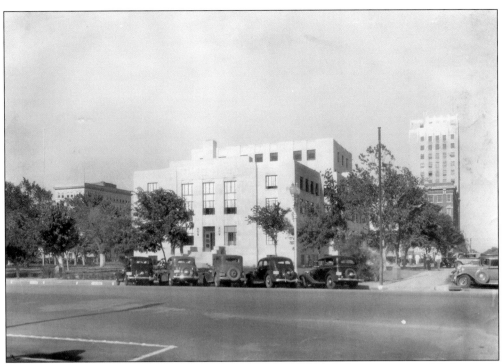

The new courthouse was dedicated August 15, 1934, and is in the more severe Modern style beloved of the 1930s. (Courtesy of Archives Division, Oklahoma Historical Society.)

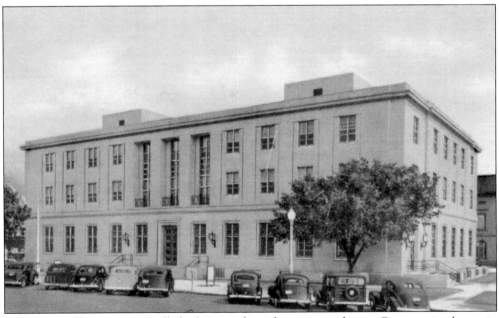

A new post office was eventually built across from the new courthouse. Construction began in 1940, and it was dedicated October 28, 1941. (Author's collection.)

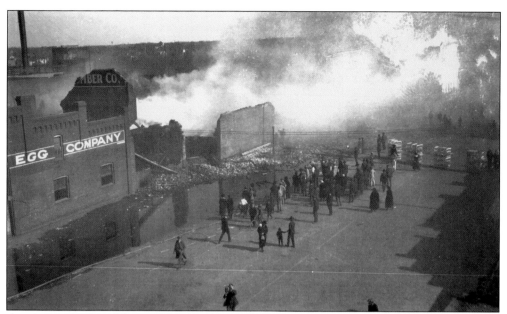

Another major fire of the period took place at the Long Bell Lumber Company at 12:41 a.m. on the morning of February 25, 1936. All available equipment in the fire department was used to combat the blaze, but still, the building was a complete loss. (Courtesy of Cherokee Strip Regional Heritage Center.)

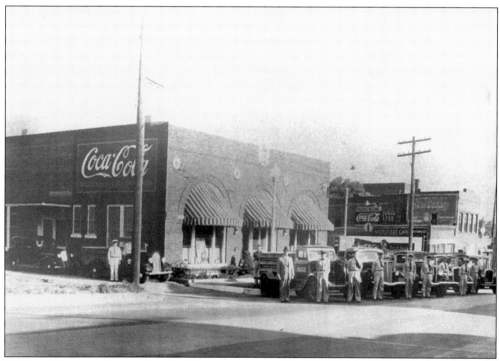

Nationwide companies continued with a major presence in the area. Here is the Enid headquarters of the Coca-Cola Company at 508 South Grand Avenue. (Courtesy of Cherokee Strip Regional Heritage Center.)

Local companies began to attract region-wide prominence. In 1925, Lewis Chenoweth went into partnership with Russell Green, forming Chenoweth and Green Music store, which lasted until 1976. Their store was on the west side of the square and was the primary source for musical instruments for all of northwest Oklahoma for many years. (Courtesy of Cherokee Strip Regional Heritage Center.)

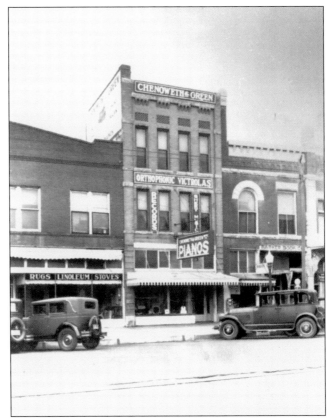

Montgomery Ward brought a major store to Enid. This picture of construction was taken sometime between 1929 and 1935. (Courtesy of Cherokee Strip Regional Heritage Center.)

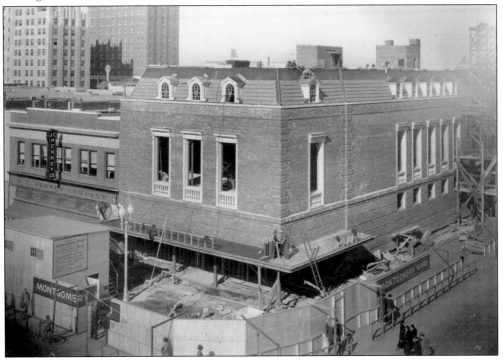

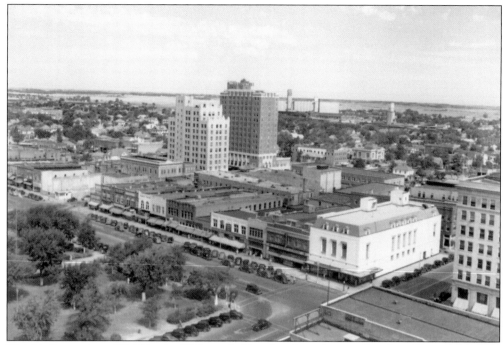

This bird's-eye view of Enid in the 1930s, probably taken from the new Broadway Tower, shows the north side of the square much as it appears today. In the background are some of the grain elevators that make Enid's skyline so distinctive. (Courtesy of Cherokee Strip Regional Heritage Center.)

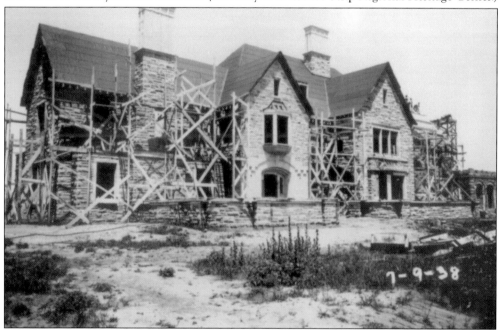

The Champlin Oil Company continued to prosper in the 1930s and 1940s. In the summer of 1938, H.H. Champlin built his new house. This mansion sits just south of west Owen K. Garriott Road and still remains in the Champlin family. The house was built by D.C. Bass Construction. (Courtesy of Cherokee Strip Regional Heritage Center.)

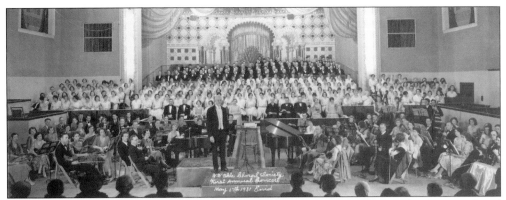

In the 1930s and 1940s, Enid became the venue for many artistic events, both musical and theatrical. Here is a group picture of the Northwest Oklahoma Choral Society's annual concert in May 1931. (Courtesy of Archives Division, Oklahoma Historical Society.)

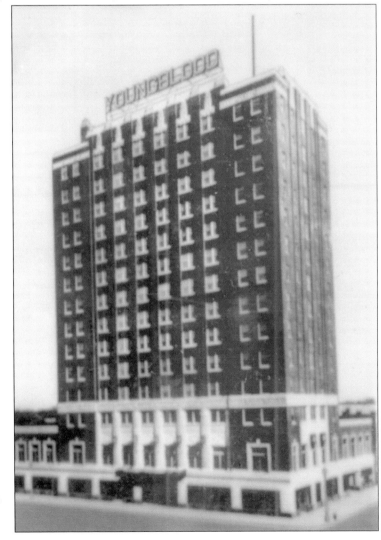

Major hotels were constructed to handle the many events Enid hosted. The Youngblood Hotel was under construction in 1929. (Courtesy of Archives Division, Oklahoma Historical Society.)

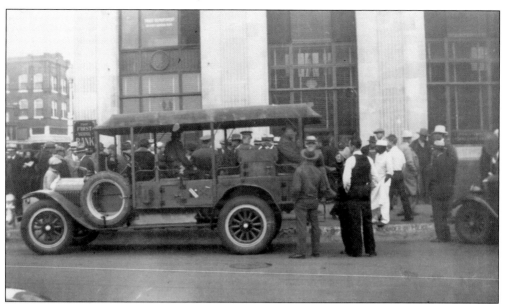

When Franklin Delano Roosevelt became president of the United States on March 4, 1933, he declared a bank holiday. Oklahoma governor William H. "Alfalfa Bill" Murray declared a state bank holiday as well. The owner of Enid's First National Bank, H.H. Champlin, refused to close his bank. Murray called out the National Guard and forced the bank to close. Here, one can see the crowd around the bank as the guard arrives. (Courtesy of Cherokee Strip Regional Heritage Center.)

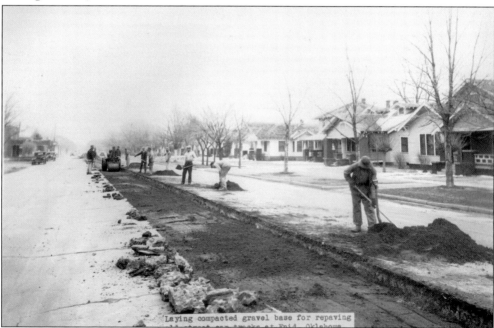

Though the Great Depression did not hit Enid as hard as some other areas of the country, the WPA (Works Progress Administration) still was able to help in projects needed to improve the town. Here, a compacted gravel base is being laid for repaving old streetcar tracks. (Courtesy of Archives Division, Oklahoma Historical Society.)

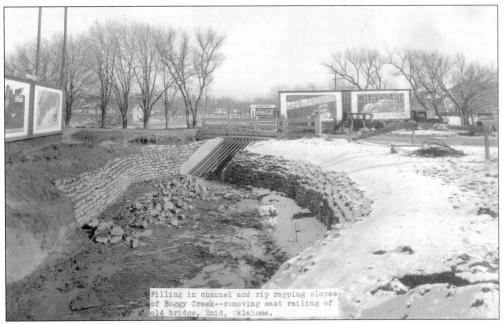

Boggy Creek ran into Government Springs Park and frequently overflowed. Here, the WPA is working on the channel and riprapping slopes of Boggy Creek and removing the east railing of an old bridge over the creek. (Courtesy of Archives Division, Oklahoma Historical Society.)

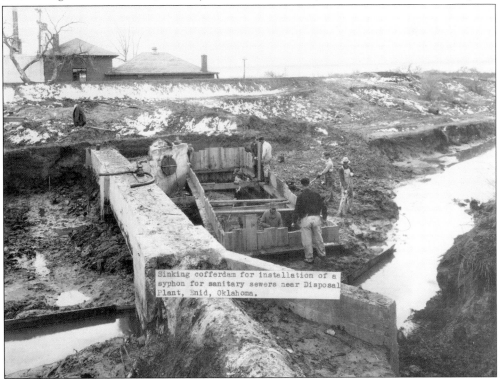

The WPA also sank a cofferdam for installation of a siphon for sanitary sewers near the waste disposal plant in Enid. (Courtesy of Archives Division, Oklahoma Historical Society.)

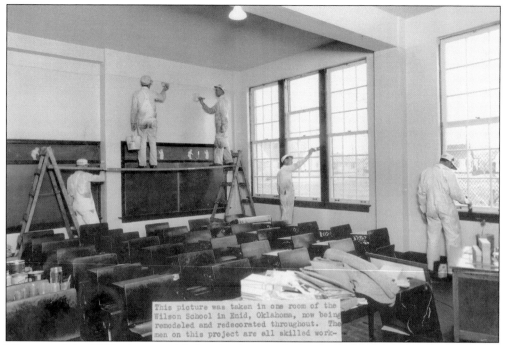

The men of the WPA also remodeled and redecorated schools. This photograph shows some of the work being done inside Wilson School in 1933. (Courtesy of Archives Division, Oklahoma Historical Society.)

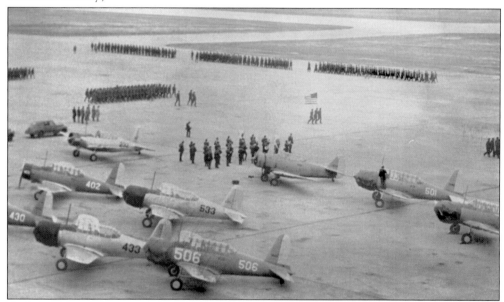

Enid Army Air Field originally started as the Air Corps Basic Flying School on September 20, 1941. It became Enid Army Flying School on February 11, 1942, and in 1943, it became Enid Army Air Field. When it was deactivated on January 31, 1947, a total of 9,895 pilots had earned their wings there. The base was reactivated on August 1, 1948, as the Enid Air Force Base, but on July 9, 1949, it was named for Lt. Col. Leon R. Vance, an Enid native. (See chapter 5 for more on Leon Vance). (Courtesy Cherokee Strip Regional Heritage Center.)

Seven

HAVING FUN

The people of Enid, like people throughout the world, want to take time to have fun. People's ideas of fun have changed over the years, but the basic gist is to find a way to relax.

As early as 1897, the Ringling Bros. Circus came to Enid, no doubt drawing people in from miles around. Carnivals continued to be a major attraction during the turn of the 20th century and into the 1920s.

Baseball has long been important to Enid. As early as 1898, there were three teams, the Enid Baseball Club, the Enid Second Nine, and the Enid First Nine. On May 7, 1908, a grand parade was held for the opening of baseball season. In the 1930s and 1940s, under various names, Enid's semiprofessional baseball teams won national championships. Recently, Enid built the David Allen Memorial Ball Park so that baseball can continue in this town.

At first, a ride in a pony cart was a good way to have fun, but then people got automobiles and showing them off was important as well as fun.

Quilting bees were an important early-day activity for women. Social clubs of every kind were important in early-day Enid life. These included the Enid Study Club, the Madrigal Club, the Home Culture Club, the Shakespeare Club, and the Merry Hearts Society. As early as 1912, Enid provided a swimming pool for its citizens.

At first, people attended shows at the opera house or a theater, but by the 1920s, motion pictures swept across the country, and Enid was no exception. At one time, there were at least nine movie theaters open in the town.

Musical events were very important, and the most important of them was the Tri-State Band Festival, started in April 1933 and now called the Tri-State Music Festival. As many as 20,000 people have participated in this festival.

The people of Enid never tire of celebrating the land run of 1893. The very next year after the land run, they had a parade celebrating it. Parades celebrating the run are a fixture of Enid to this day, as the people of Enid never want to forget how the town started and how it developed.

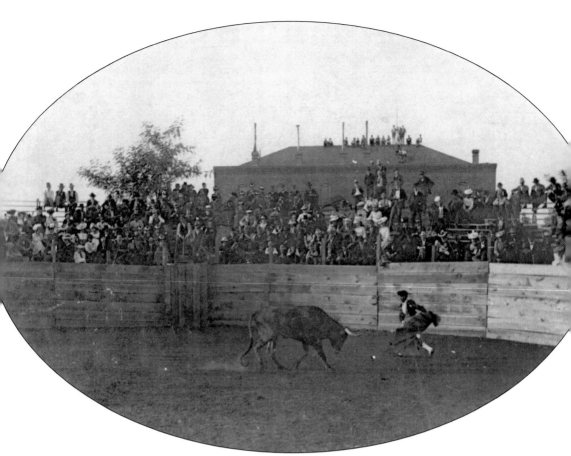

This photograph is the only evidence of a bullfight ever having taken place in Enid. Considering the first courthouse building is in the background, the photograph was taken sometime after 1896. (Courtesy of Cherokee Strip Regional Heritage Center.)

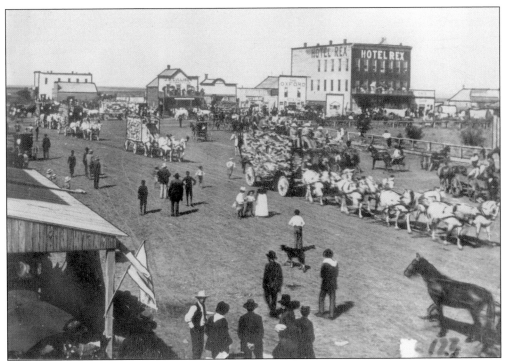

The Ringling Bros. Circus came to town in September 1897. (Courtesy of Cherokee Strip Regional Heritage Center.)

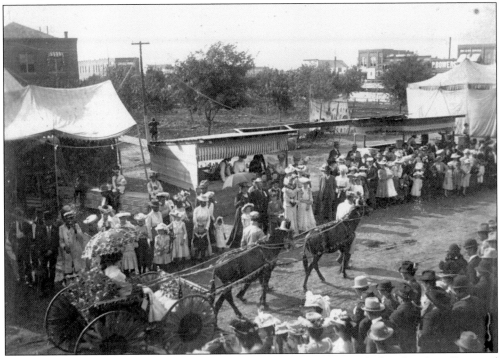

This very well may be an Easter parade from about 1900. (Courtesy of Cherokee Strip Regional Heritage Center.)

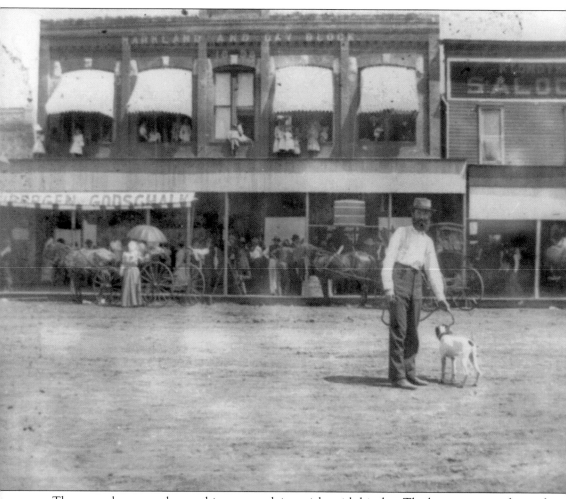

These people seem to be watching a man doing tricks with his dog. The largest store in front of which this happened was that of Meibergen and Godschalk. Marinus Godschalk, with his cousin Joseph Meibergen, opened this store in 1895 at 109 North Grand Avenue. Joseph Meibergen was mayor of Enid at one time. Note the young children sitting in the open windows. (Courtesy of Cherokee Strip Regional Heritage Center.)

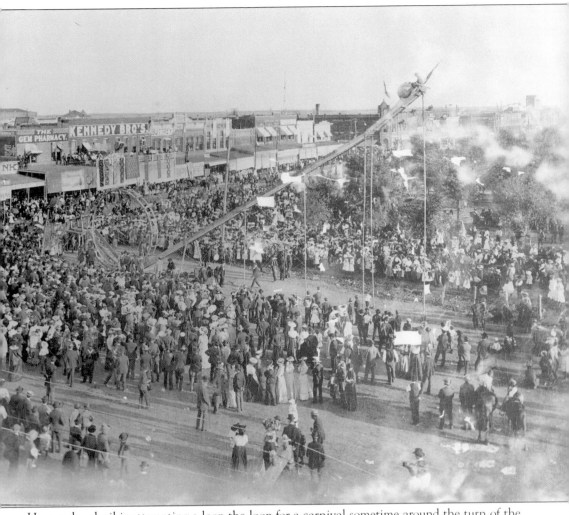

Here, a daredevil is attempting a loop the loop for a carnival sometime around the turn of the 20th century. (Courtesy of Cherokee Strip Regional Heritage Center.)

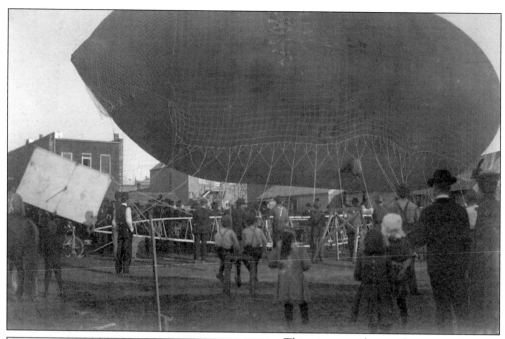

This picture, taken perhaps as early as 1897, shows a dirigible ascension in the center of town. It is not known how much was charged for a ride. (Courtesy of Sons and Daughters of the Cherokee Strip Pioneers, Enid.)

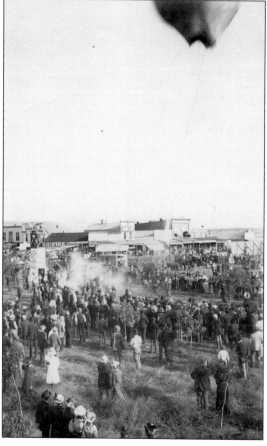

Here is a hot-air balloon ascension, perhaps from the very first celebration of the land run in 1894. (Courtesy of Cherokee Strip Regional Heritage Center.)

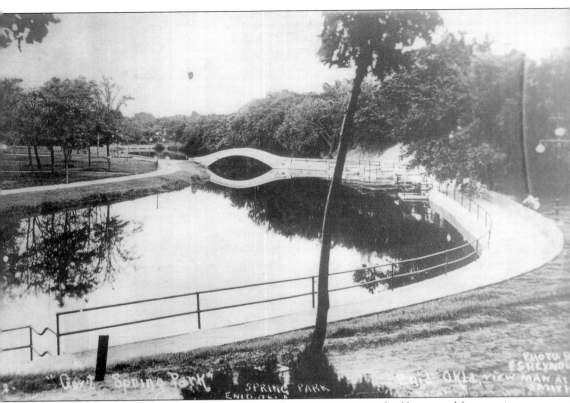

In the eastern portion of the townsite, five naturally occurring springs had been used for watering cattle on the old Chisholm Trail. After the town had been settled, the springs were channeled into a small lake, which was the center of Government Springs Park. (Author's collection.)

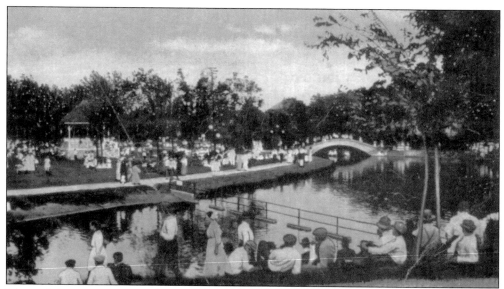

The park became a major gathering spot for the people of Enid. (Author's collection.)

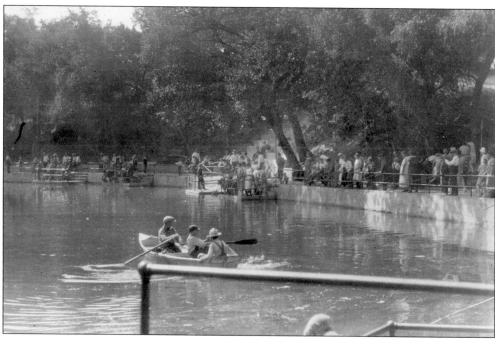

Government Springs Park is seen here in the 1930s. The lake is still the center of the park in Enid today. (Courtesy of Cherokee Strip Regional Heritage Center.)

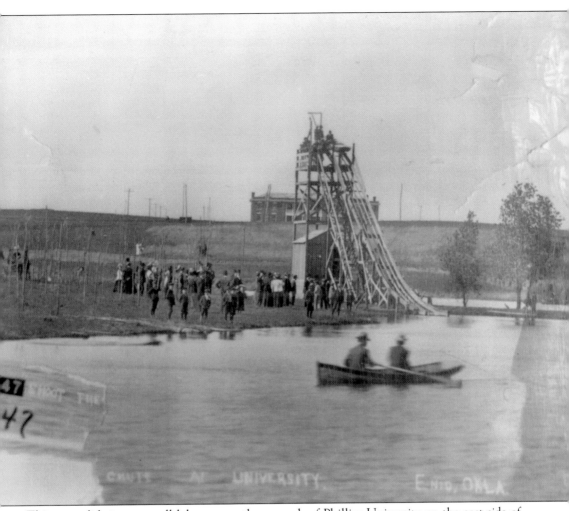

This waterslide into a small lake was on the grounds of Phillips University on the east side of town. In the background, one can see a university building. (Courtesy of Cherokee Strip Regional Heritage Center.)

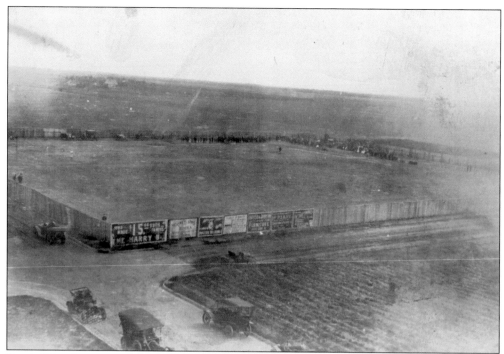

Baseball has been very important to Enid. Pictured is the early baseball field, which stood about where the Kmart stands on West Owen K. Garriott Road. (Courtesy of Cherokee Strip Regional Heritage Center.)

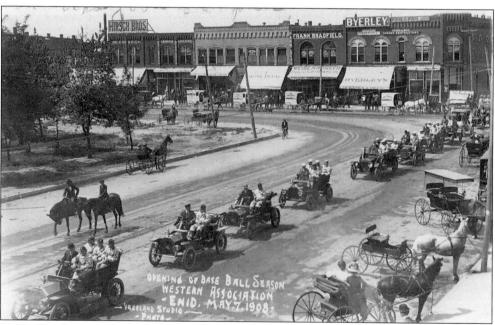

Held in Enid on May 7, 1908, this is a parade celebrating the opening of baseball season for the Western Association. (Courtesy of Cherokee Strip Regional Heritage Center.)

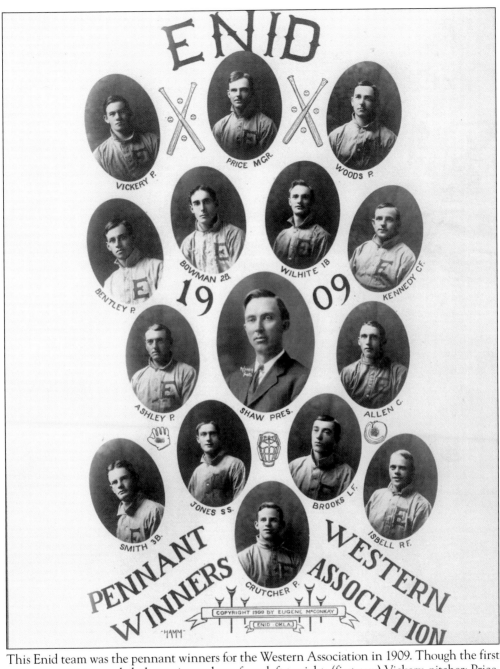

This Enid team was the pennant winners for the Western Association in 1909. Though the first names were not recorded, those pictured are, from left to right, (first row) Vickery, pitcher; Price, manager; and Woods, pitcher; (second row) Bentley, pitcher; Bowman, second base; Wilhite, first base; and Kennedy, center field; (third row) Ashley, pitcher; Shaw, president; and Allen, catcher; (fourth row) Smith, third base; Jones, short stop; Brooks, left field; and Isbell, right field; (fifth row) Crutcher, pitcher. (Courtesy of Cherokee Strip Regional Heritage Center.)

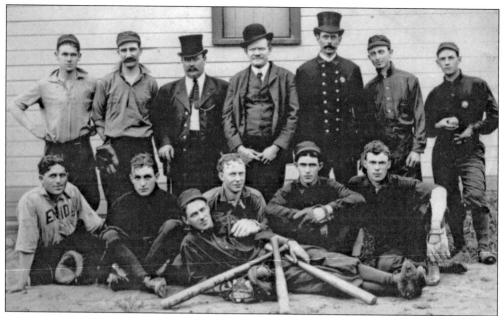

Sources are divided over whether this is a baseball team of the police department, the fire department, or perhaps both. (Courtesy of Cherokee Strip Regional Heritage Center.)

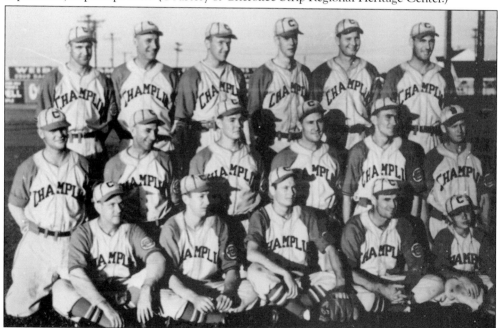

During the 1930s and 1940s, Enid baseball teams won national championships. The Champlin Refiners are pictured here in 1940. Unfortunately, the picture is not labeled, but members were Nick Urban, manager; Cecil McClung, utility; J.D. "Red" Barkley, short stop; Gene Gibson, third base; Howard McFarland, center field; Frank Clift, right field; Jim Keesey, first base; John Heath, pitcher; Lil Stoner, pitcher; George Milstead, pitcher; Dallas Patton, left field; Vance Cauble, pitcher; Glen Mcquiston, pitcher; Verdon Gilchrist, second base, Keith Clarke, catcher; and Eddie Reeser, catcher. (Courtesy of Cherokee Strip Regional Heritage Center.)

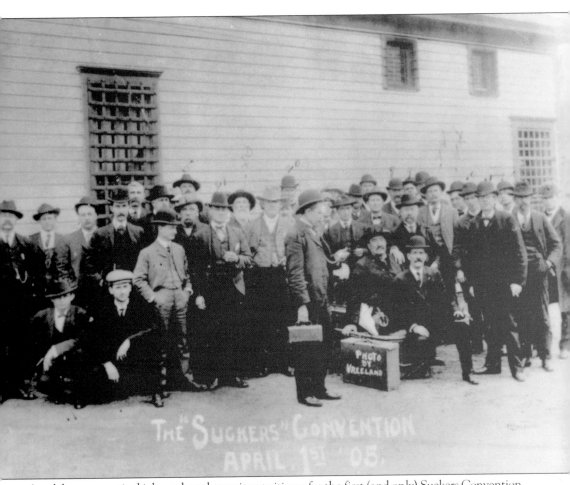

An elaborate practical joke gathered prominent citizens for the first (and only) Suckers Convention in Enid on April 1, 1905. Those pictured are 1.) unidentified, 2.) Roy Wirt, 3.) Dr. W.A. Holdeman, 4.) a Mr. White, jailer, 5.) a Mr. Bohannan, 6.) John Milligan, 7.) Frank Letson, 8.) J.L. Isenberg, 9.) Hank Billings, 10.) Tom Hunter, 11.) W.O. Cromwell, 12.) Jas. B. Cullison, 13.) Horace McKeever, 14.) Dr. J.W. Boyle, 15.) Houston James (father of Marquis James), 16.) Dr. Champion, 17.) Chris West, 18.) G.J. Vreeland, photographer, 19.) unidentified, 20.) Karl Kruse, and 21.) William Hills. (Courtesy of Cherokee Strip Regional Heritage Center.)

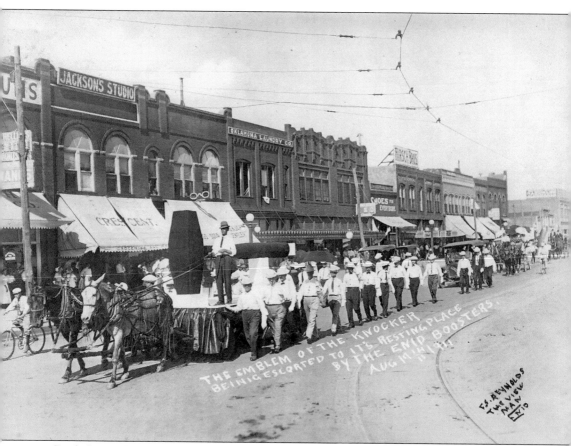

Enid also made elaborate excuses for a parade. This photograph is entitled "The Emblem of the Knocker being escorted to its resting place by the Enid Boosters, August 17, 1911." The idea was to discourage the citizens of Enid from knocking, that is downgrading, their town in discussions with other people. (Courtesy of Cherokee Strip Regional Heritage Center.)

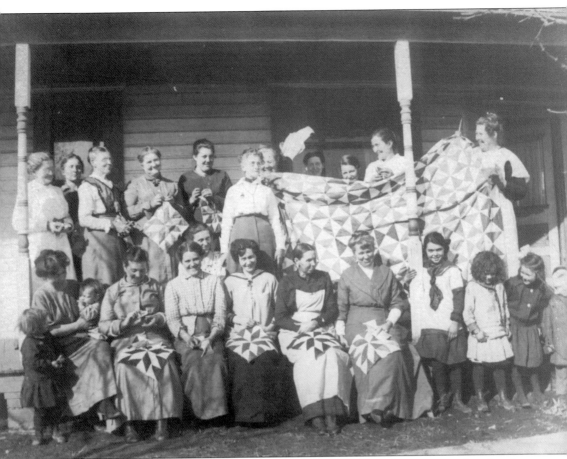

Quilting was a well-established pastime for the women of Enid. Minnie Gigoux is standing fourth from the left. The pattern of the quilt seems to be a pinwheel. (Courtesy of Cherokee Strip Regional Heritage Center.)

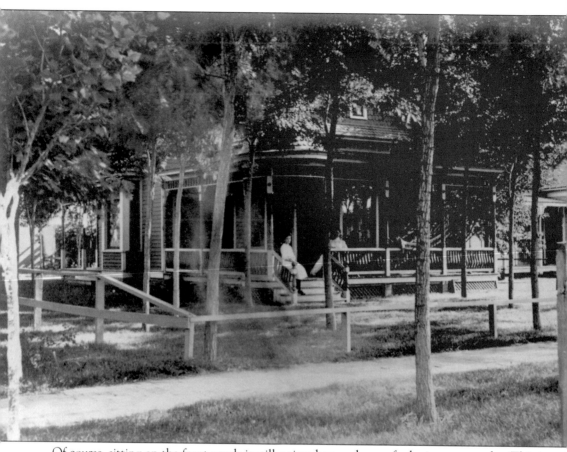

Of course, sitting on the front porch is still a time-honored way of relaxing, even today. This is the shady residence of W.W. English at 524 West Wabash. (Courtesy of Cherokee Strip Regional Heritage Center.)

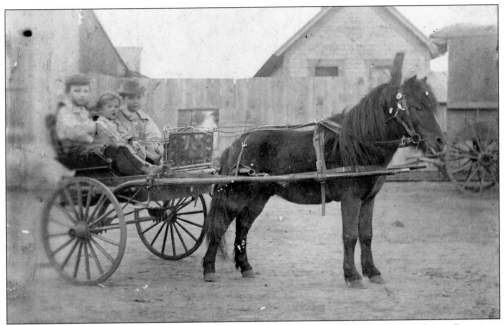

Here, three unidentified children take a ride in a pony cart. (Courtesy of Archives Division, Oklahoma Historical Society.)

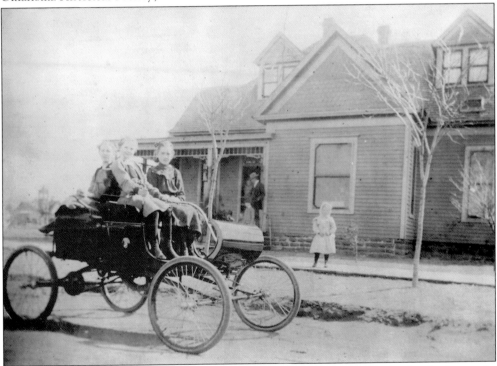

The first car in Enid belonged to banker Sherman T. Goltry. He paid $650 plus freight charges for an Oldsmobile Roadster that arrived on the train three days after Christmas in 1901. Pictured are the Goltry children in front of their home on 1002 West Maple Avenue. (Courtesy of Cherokee Strip Regional Heritage Center.)

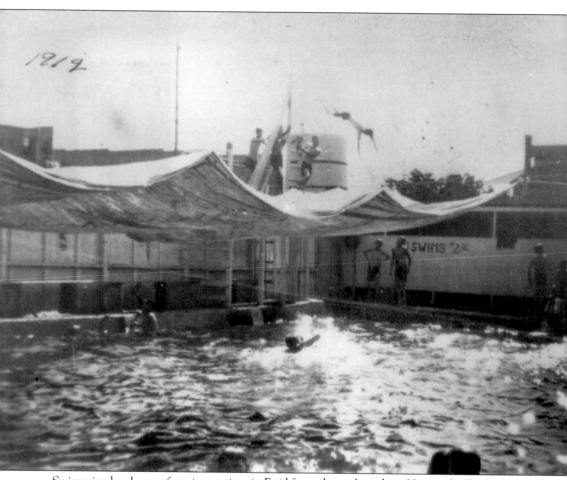

Swimming has been a favorite pastime in Enid from the earliest days. Here is the Enid swimming pool in 1912. (Courtesy of Cherokee Strip Regional Heritage Center.)

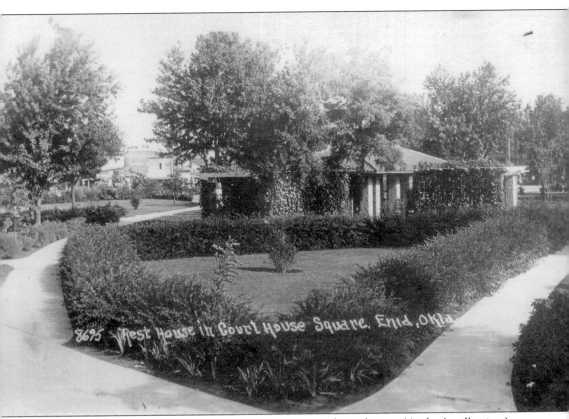

A visit to the gardens that surrounded the courthouse was often relaxing. (Author's collection.)

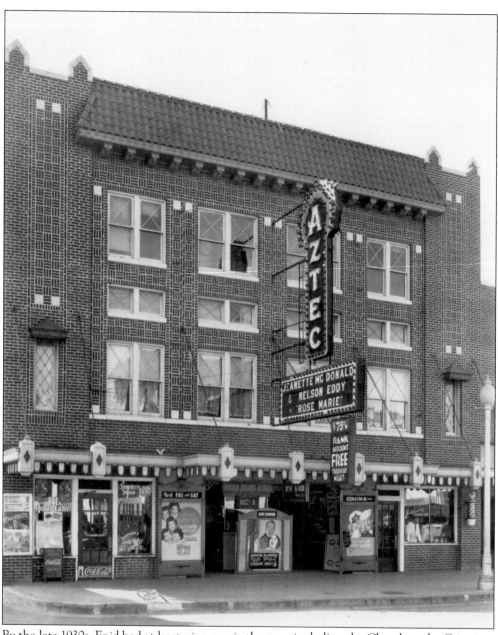

By the late 1930s, Enid had at least nine movie theaters, including the Cherokee, the Criterion, the Royal, the Chief, the Arcadia, and the Mecca. This picture is of the Aztec Theater, located at 215 West Randolph Avenue. This photograph dates to 1928 as the movie being shown is *Rose Marie*, starring Jeanette McDonald and Nelson Eddy. (Courtesy of Archives Division, Oklahoma Historical Society.)

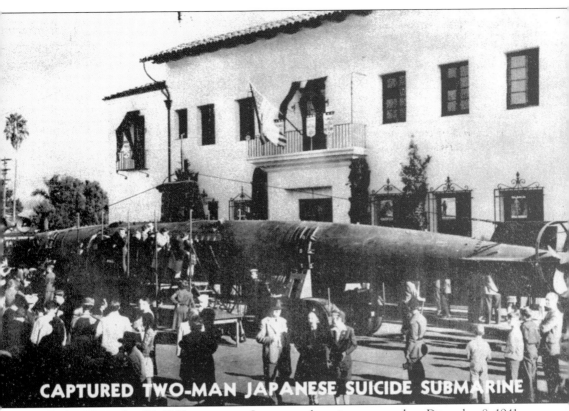

CAPTURED TWO-MAN JAPANESE SUICIDE SUBMARINE

On Friday, November 26, 1943, a two-man Japanese submarine, captured on December 8, 1941, at Pearl Harbor, was brought to Enid to the Aztec Theater to be on display from 10:00 a.m. until 2:00 p.m. This was sponsored by the War Savings Council of the Treasury Department, no doubt to sell war bonds. The submarine is seen above, though the building in the background is not the Aztec Theater. (Courtesy of Bernie Mayer.)

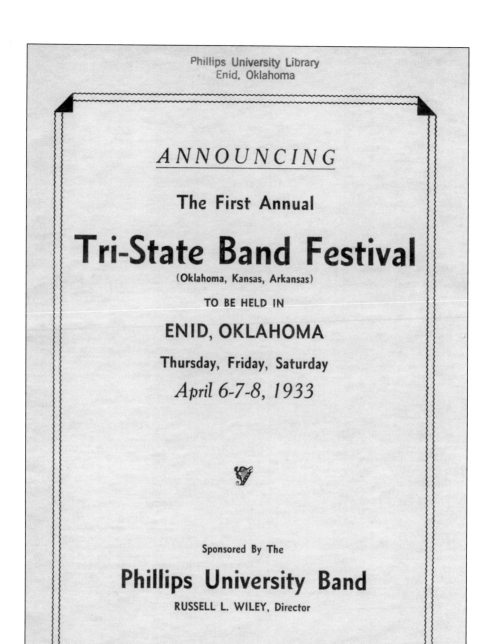

ANNOUNCING

The First Annual

Tri-State Band Festival

(Oklahoma, Kansas, Arkansas)

TO BE HELD IN

ENID, OKLAHOMA

Thursday, Friday, Saturday

April 6-7-8, 1933

Sponsored By The

Phillips University Band

RUSSELL L. WILEY, Director

Separate and Apart from any National, State or District Contest

Known as the Tri-State Band Festival until 1950, the Tri-State Music Festival is still one of the most important music festivals in Oklahoma. Its parade was sometimes called the "Million Dollar Parade" because of the value of the instruments used by the students. As many as 22,000 participants have marched in a single Tri-State parade. (Courtesy of Cherokee Strip Regional Heritage Center.)

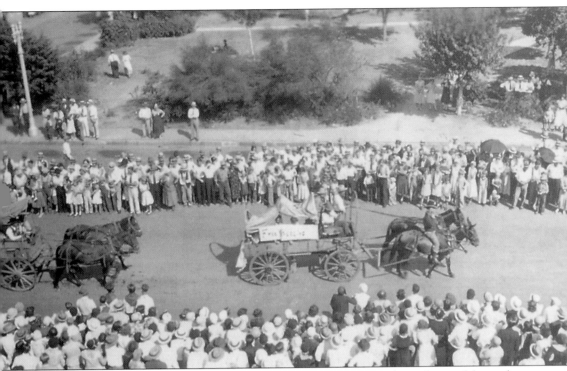

To this day, on a Saturday close to September 16, Enid throws a grand parade to celebrate the land run of September 16, 1893. Here is a celebration from about 1935. (Courtesy of Cherokee Strip Regional Heritage Center.)

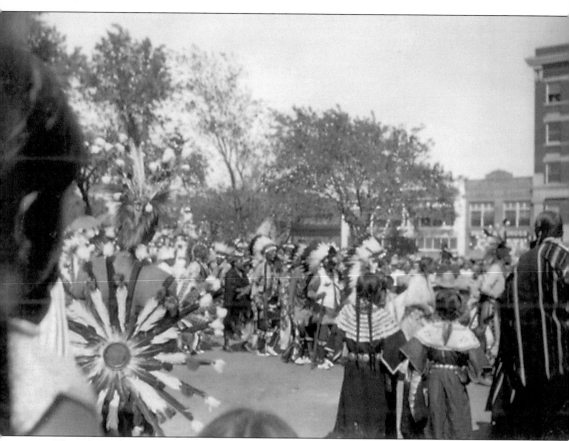

Though Enid was never the home of Native Americans, many different tribes came to take part in the Cherokee Strip Parade. (Courtesy of Cherokee Strip Regional Heritage Center.)

Here, some men relax while either waiting for their turn in the parade or having already marched in it. Perhaps they are thinking of what they will do in the Cherokee Strip Parade next year. (Courtesy of Cherokee Strip Regional Heritage Center.)

DISCOVER THOUSANDS OF LOCAL HISTORY BOOKS FEATURING MILLIONS OF VINTAGE IMAGES

Arcadia Publishing, the leading local history publisher in the United States, is committed to making history accessible and meaningful through publishing books that celebrate and preserve the heritage of America's people and places.

Find more books like this at
www.arcadiapublishing.com

Search for your hometown history, your old stomping grounds, and even your favorite sports team.